**fa** **Famous Artists School**

# How to Draw Animals

### Harold Von Schmidt
Working as a cowhand and muleskinner gave Harold Von Schmidt an intimate knowledge of animals—which he was able to translate into some of the finest and most widely acclaimed pictures of the old West. Not only does his work show complete mastery of drawing and painting, but it reflects the honesty and authenticity that is synonymous with the name Harold Von Schmidt.

### Ben Stahl
From the time he won an art school scholarship while in his teens, Ben Stahl has impressed both the public and his fellow artists with the versatility and power of his drawings and paintings. With his generosity of spirit, he has always been glad to use part of his time teaching and inspiring others.

### Franklin McMahon
One of the most traveled artists of our time, Franklin McMahon has drawn on the site such various activities as the Ecumenical Council in Rome, children at play in Bangkok and a crowded airport in Bombay.

So successful has McMahon been that his unique drawings and paintings are in demand by top magazines, large corporations, and television. He was named "Artist of the Year" by the famed Artists Guild.

### Fred Ludekens
To Fred Ludekens there are a few good rules to follow in becoming an artist: observe, remember, think—and draw, draw, draw! As a young student Ludekens amazed his instructor with a poster design of race horses. This was the start of a career filled with a constant stream of spectacular animal drawings and paintings for top magazines and advertising campaigns.

### Stevan Dohanos
Every picture created by realist Stevan Dohanos is endowed with a startling, sensitive magic—whether it is a magnificent eagle or a lowly chicken, fireplug, or a telephone pole. Winner of numerous awards, Dohanos has paintings and prints bearing his signature in the collections of many art museums.

# Learn ANIMAL DRAWING with the easy-to-follow methods of these FAMOUS ARTISTS!

The Famous Artists School series of books pools the rich talents and knowledge of a group of the most celebrated and successful artists in America. The group inludes such artists as Norman Rockwell, Albert Dorne, Ben Stahl, Harold Von Schmidt, and Dong Kingman. The Famous Artists whose work and methods are demonstrated in this volume are shown at left.

The purpose of these books is to teach art to people like you—people who like to draw and paint, and who want to develop their talent and experience with exciting and rewarding results.

*Contributing Editor*
**Walt Reed**

#### PUBLISHER'S NOTE
This new series of art instruction books was conceived as an introduction to the rich and detailed materials available in Famous Artists School Courses. These books, with their unique features, could not have been produced without the invaluable contribution of the General Editor, Howell Dodd. The Contributing Editors join me in expressing our deep appreciation for his imagination, his unflagging energy, and his dedication to this project.

Robert E. Livesey, *Publisher*

# How to Draw Animals

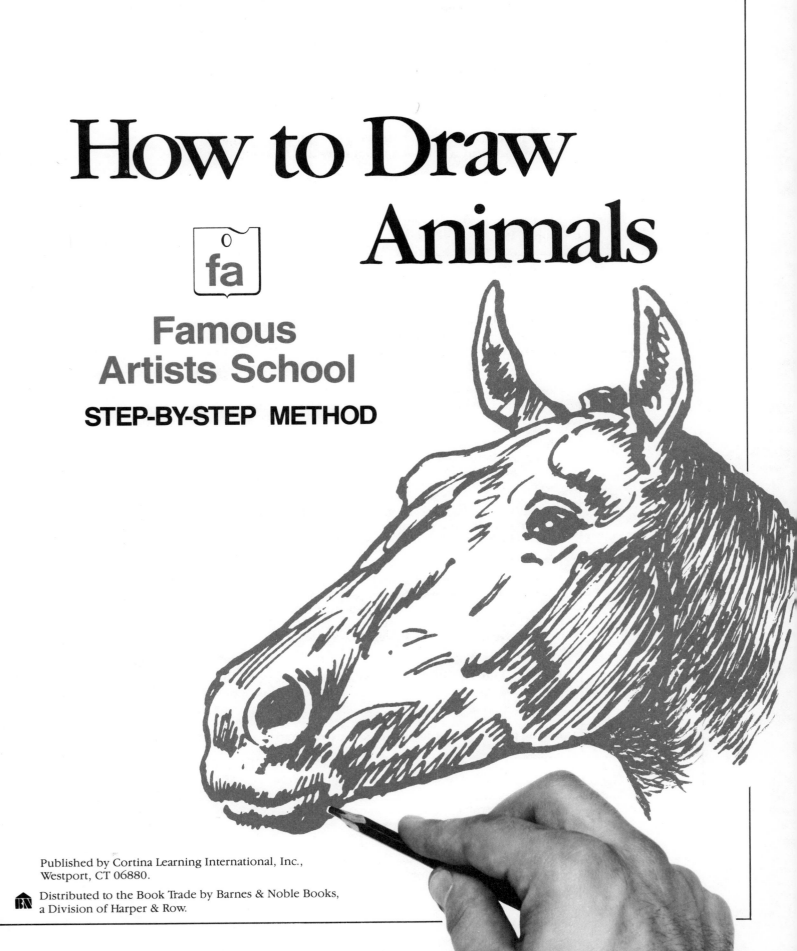

**fa**

## Famous Artists School

### STEP-BY-STEP METHOD

Published by Cortina Learning International, Inc.,
Westport, CT 06880.

Distributed to the Book Trade by Barnes & Noble Books,
a Division of Harper & Row.

# How to Draw Animals
## Table of Contents

ISBN 0-8327-0900-X        ISBN 0-06-464068-X

*Designed by Howard Munce*

*Composition by Typesetting at Wilton, Inc.*

# Your Practice Projects...*how they teach you*

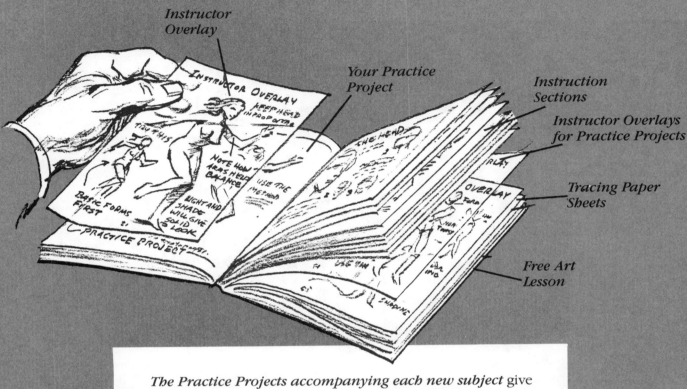

The **Practice Projects accompanying each new subject** give you the opportunity to put into immediate practice what you have just learned.

You can draw directly on the Project pages, using ordinary writing pencils, or take a sheet of tracing paper from the back of the book and place it over the basic outline printed in the Project and make experimental sketches. Also, you can trace the printed outline and transfer it onto any other appropriate paper. (The transfer method is explained on page 96.)

**Instructor Demonstrations for the Projects** are located in the last section of the book. They are printed on tracing paper overlays. You can remove them and place them either over your work or over white paper so you can study the corrections and suggestions.

**Do not paint on Practice Project pages.** This would damage the pages and spoil your book. If you wish to paint with watercolors you can obtain appropriate papers or pads at an art supply store. For oil paints you can get canvas, canvasboards or textured paper.

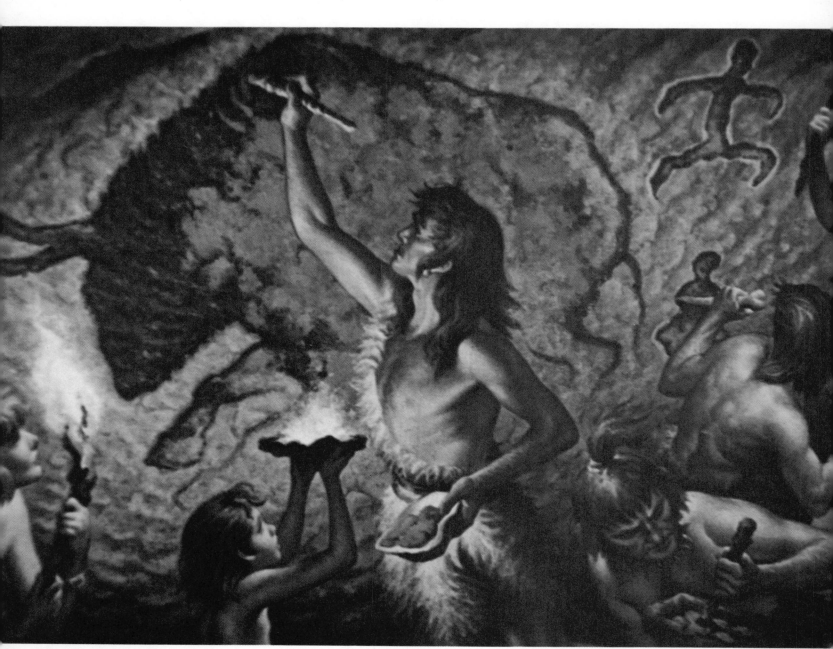

Painting by Jules Gotlieb
Courtesy Illustration House, Inc.

6

# The Wonderful World of Animal Drawing

**The oldest drawings on earth**—drawings that are older than history itself—are pictures of animals. Artists of the Stone Age painted them on the walls of caves in France and Spain. Working with colors made from minerals and burnt bones, these first artists painted bison and deer, boars and horses, with a vigor, realism, and freshness of style that are the envy of today's best artists.

One reason the cavemen drew their animals so well was that they knew them first-hand. Whether you've studied animals for years or are just beginning, this book will make it easier for you to draw them convincingly. It places at your disposal the knowledge and experience of some of the best animal artists of our time, faculty members of Famous Artists School. Mindful of how difficult it was and how long it took them to learn their art, they have reduced their dearly won knowledge to simple step-by-step methods. As you progress, you have periodic reviews and Practice Projects that help you make sure you've learned everything you should have. Through these techniques, the art of drawing animals becomes a rich and rewarding experience.

The Famous Artists start by showing you a direct, simple method of drawing four basic animals—the cat, dog, horse, and cow—at rest and in motion. These four are your prototypes—once you've learned to draw them, your teachers show you how to extend your knowledge to other animals, like the lion, the bear, and the giraffe.

Drawing birds is a challenge, but with the easy-to-follow instructions in this volume it will become a fascinating, enriching experience for you. Bird anatomy, how a bird folds its wings, how it flies, are all explained in helpful detail.

Animals are fun to know. They're even more fun to draw. All you need is a sketchpad and a pencil and a willingness to learn. That learning will give you great pleasure as you advance from one easy lesson to the next under the skilled direction of some of the best art teachers of this generation.

Harold
Von
Schmidt

# Working Tools

## Pencils.
*Ordinary writing pencils are fine* for your Practice Project drawings. They come in grades ranging from soft to medium and hard leads. The soft pencils give you broader, darker lines and tones. Pencils used by professional artists come in leads ranging from 6B (very soft) to 9H (very hard).

## *How to sharpen pencils.*
*A regular pencil sharpener* gives a sharp, even point. You can also sharpen your pencil with a single-edge razor blade and finish by shaping the point on a sandpaper pad or any fine grain sandpaper. For a wide, chisel-like point, rub the point on the sandpaper without rolling it.

## Erasing.
*A medium soft eraser*, such as a pink pearl or the eraser on the end of a writing pencil, is good for most erasures. Another useful type is a kneaded eraser which can be shaped to a point by squeezing it between your fingertips.

## Charcoal.
*This wonderfully responsive medium* comes in three forms. There is the natural charred stick commonly called "vine charcoal." Then there are two synthetic forms. One is a pencil and the other a chalk about 3 inches long. All three forms come in varied degrees of softness (blackness). Natural charcoal is the most subtle and it erases most easily, using a kneaded eraser. The pencil kind is the least brittle and cleanest to handle.

Hold your pencil any way you find comfortable. The writing grip is a good position for carefully controlled lines and details.

The under-the-palm grip is good for working larger or more freely as when sketching outlines or shading.

**Papers.** *Drawing papers have different surfaces*—slick, average or rough (artist refer to the latter as having "tooth"). The Practice Projects are planned so you can draw directly on them. You will also find sheets of transparent tracing paper at the back of the book. For additional practice sketching, typewriter paper is good. A pad of drawing paper, or common newsprint can be purchased at an art supply store where you can also get white and tinted charcoal paper. Another good type of practice paper is a roll of commercial white wrapping paper (but be sure it is not the kind with a wax surface).

## Easel or Drawing Board. *Fasten your paper with tape*, thumbtacks or push

pins to any light, firm board. Put a smooth piece of cardboard or several thicknesses of paper under your top sheet so rough or uneven spots on the board won't interfere with your drawing. An easel is fine to support the board, but you can prop it in your lap and either hold it with your outstretched arm or rest it against any firm object. Another good method is to prop the board on the seat of a straight-backed chair. The seat then makes a good place to hold pencils and erasers.

# Where to Draw Animals

*Drawing animals is like drawing people, landscapes, still life* or anything else. You'll have more success when you work from the real thing. In drawing animals, use living models whenever you can. They'll give you the spontaneity, the sense of animal spirit that you must bring to your drawing if it's to look convincing and alive.

You may be a little shy about drawing in public, but just try to concentrate very hard on your work and you'll soon forget that anyone else is around. Don't carry a lot of equipment with you. All you need is a sketchbook and a pencil —although you might want to take along a pen and some charcoal for variety.

## At museums

Although stuffed and mounted animals aren't alive, they do stay still! That means you'll have all the time you need to study their proportions and characteristics.

Harold Von Schmidt

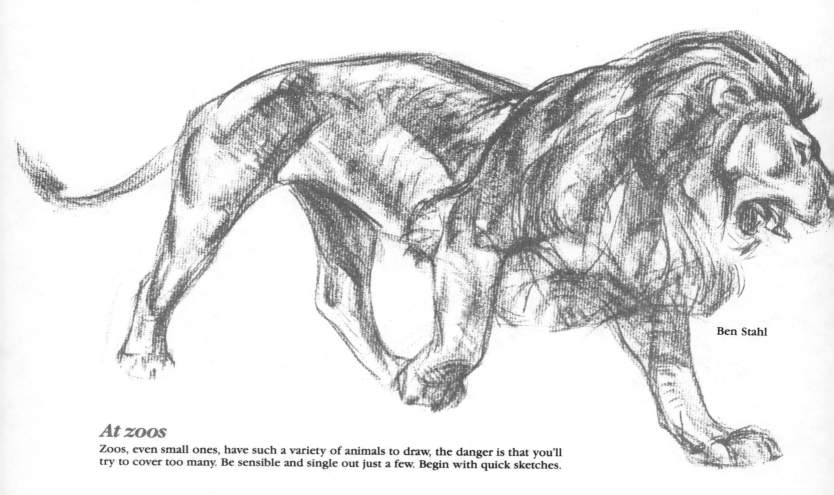

Ben Stahl

## At zoos

Zoos, even small ones, have such a variety of animals to draw, the danger is that you'll try to cover too many. Be sensible and single out just a few. Begin with quick sketches.

## At farms

If you can get to a farm, go there often and draw.
It's helpful to observe and sketch animals in their
natural surroundings. Too, you'll like the freedom
of being all alone, away from the public eye.

## At events

Events, like rodeos, circuses,
parades, county fairs, horse and
dog shows, are all loaded with
good animal subjects. You may
have to sketch very fast, as
Franklin McMahon did
with this sketch made
at a rodeo.

Franklin McMahon

## At home

Cat, dog, bird, fish, rabbit, turtle, snake—whatever
kind of pet you have, draw him over and over, in dif-
ferent positions and moods. Dogs make good subjects
because they're usually up to something. Sketch yours
when he's eating, sleeping, running, scratching, stretch-
ing, digging for a bone, barking and begging.

Lorraine Fox

## "But they won't hold still..."

**Unlike your friends**, animals can't be cajoled into staying still while you draw them. You just have to have your pencil ready whenever they decide to quiet down.

Dogs and cats love to take naps—you can make dozens of sketches of them before they wake up. You'll have to work faster if you want to draw them when they eat. Don't linger over any one part very long. The important thing is to catch the essential pose, the expression of the whole body before the animal moves. You can develop your sketch in more detail if you want to, later on.

# The Sketchbook Habit

*The way to learn to draw is by drawing* —no matter how weak your first efforts may appear. You will accomplish two things in the process. You'll learn to look with greater concentration, to observe the subtle details that make up the larger shapes. You'll also find that you will develop a dexterity with your pencil or pen the more you use it.

An ideal way to acquire these drawing skills is through the sketchbook habit. Carry a pocket-sized pad or sketchbook with you wherever you go. You should be amazed at the difference between your first drawings and the ones at the back of the pad.

13

# The Dog's Head—*step by step*

*Simple forms are the key* to starting a drawing. As demonstrated here, the structure of all dogs' heads, no matter what breed, resembles two basic shapes joined together. The segment involving the top of the head, brow, and eyes is almost like a cube, rounded at the corners. Next to it is an extended, almost triangular form, corresponding to the length of the nose and mouth. Try this on a page of your sketchbook.

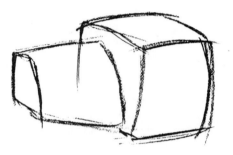

**1.** Block in these shapes lightly (you're going to draw over them).

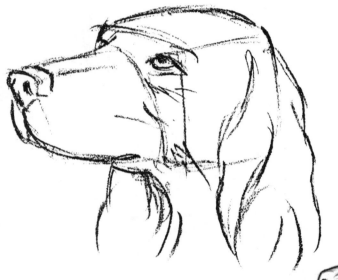

**2.** Next, add to your first sketch by blocking in the eyes, nose, ears, mouth and tongue.

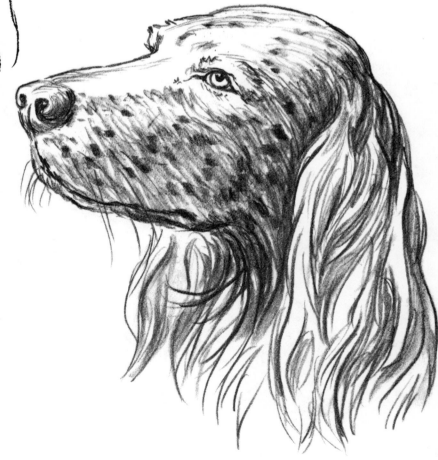

**3.** Finally, refine the drawing by simply adding the details to the blocked-in shapes, and erasing unwanted construction lines.

# Practice Project

*Your first three Practice Projects*, in which you'll draw heads of a dog, a cat and a horse, are planned with two main purposes in mind:

**1. *Pencil control.*** You can learn to create lines and tones with the two ways of holding your pencil shown on page 8: the writing grip for details, and the under-the-palm grip for broad, free strokes.

**2. *Basic form drawing.*** The simple, basic forms shown on the step-by-step demonstrations on the pages facing the Practice Projects must be kept in mind, even though you have outlines as guides.

Draw with a soft pencil, directly on these pages. Don't try to copy, stroke for stroke, but work to get the same character as the original drawing. Afterwards, you may wish to repeat the drawings, freehand, on separate sheets.

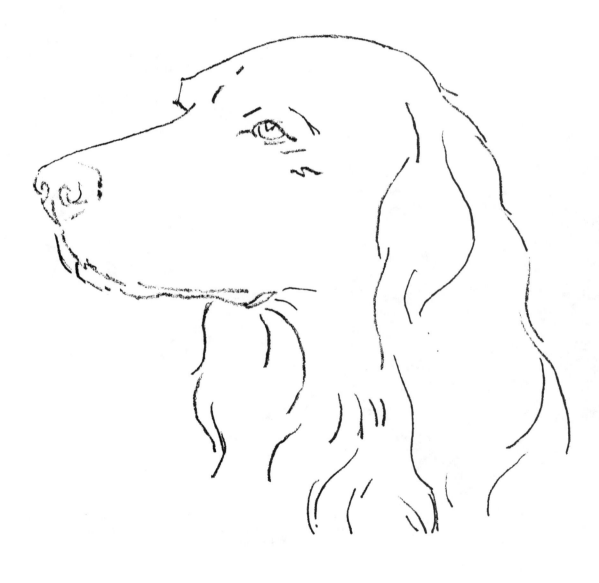

# The Cat's Head... *step by step*

*Like the heads of dogs*, all cat species have their own family shape. The household cat is an excellent model to begin with. Here the basic shape is round, almost like a ball, with a projecting snout. Note that this second section tapers and is much shorter than in the dog. Again, try these drawing steps in your sketch pad.

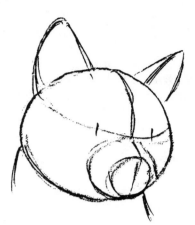

**1.** Start with a simple circle but think of it as a three-dimensional ball. Then add the short frontal section.

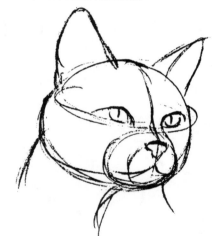

**2.** As you block in the other details, note how the eyes and the base of the ears are located on a line going around the head.

**3.** Once you have located the positions of the features and added the details, you can erase the lightly-drawn first construction lines.

# Practice Project

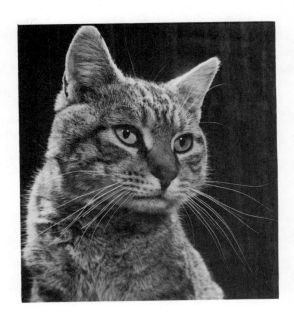

*This cat's head* will give you another chance to experiment with pencil strokes to create form and texture. Be sure to keep in mind the simple, basic forms. Working in pencil, you'll find it easier to leave out the black background and "halo" lighting, as the artist did on the facing page. Later, you might try scratchboard, a special drawing board and technique, where you scrape out white lines from a black background with a sharp instrument.

# The Horse's Head... *step by step*

*In some ways the horse's head* is more complicated to draw, but like the dog and cat, it is possible to find the larger structural shapes that distinguish it and its family from other species. If you will follow the same suggested step-by-step procedures, you will find that you can end up with a well-drawn head. As a reminder, however, do not be impatient to get to finished details. If your underlying structure is not right from the beginning, your final drawing will not be right either.

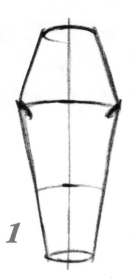

*1*

Sketch a tapering cylinder and divide it in thirds. Add the center line and place the eyes one-third down from the top. The width here is about one-third the length.

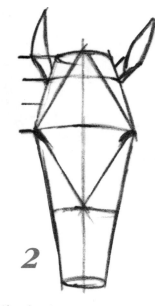

*2*

Sketch a diamond shape in the upper two-thirds to help establish the planes of the forehead. Locate the ears one-third of the way from top of head to eyes.

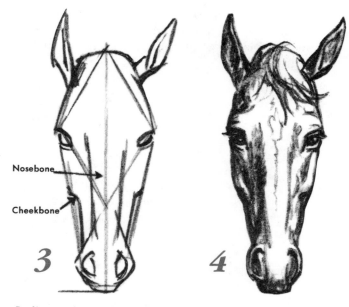

*3*

Indicate the nosebone and sketch in the nostrils. About halfway from the ear to the lip, locate the corners of the cheekbones. Narrow the head from here to the nostrils.

*4*

Add shading to show the side planes of the nose and indicate the bony structure over the eyes. Be sure to show the thickness of the eyelids, ears and nostrils.

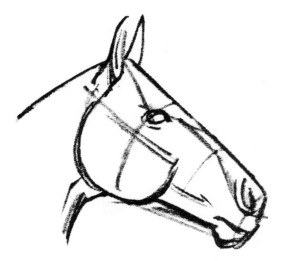

In the side view, sketch the disc shape of the cheek and jaw, and a line below the eye showing the cheek bone. Divide the muzzle in thirds with lower lip and chin in the bottom third and the nostril in the upper third.

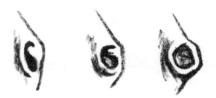

The nostril varies from a narrow slit (shaped like a "6") to a full circle.

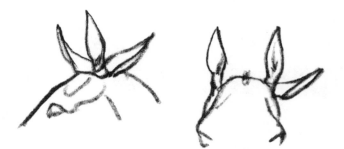

The ears have a wide range of movement.

18

# Practice Project

*In this drawing* you'll see how the blocking-in method shown on the facing page will help when the horse's head is turned at an angle. Note how the diamond shape of the forehead and the line running along the center of the face from forehead to nose helps locate the eyes and nostrils.

    This is an ideal subject for drawing in either pencil or pen.

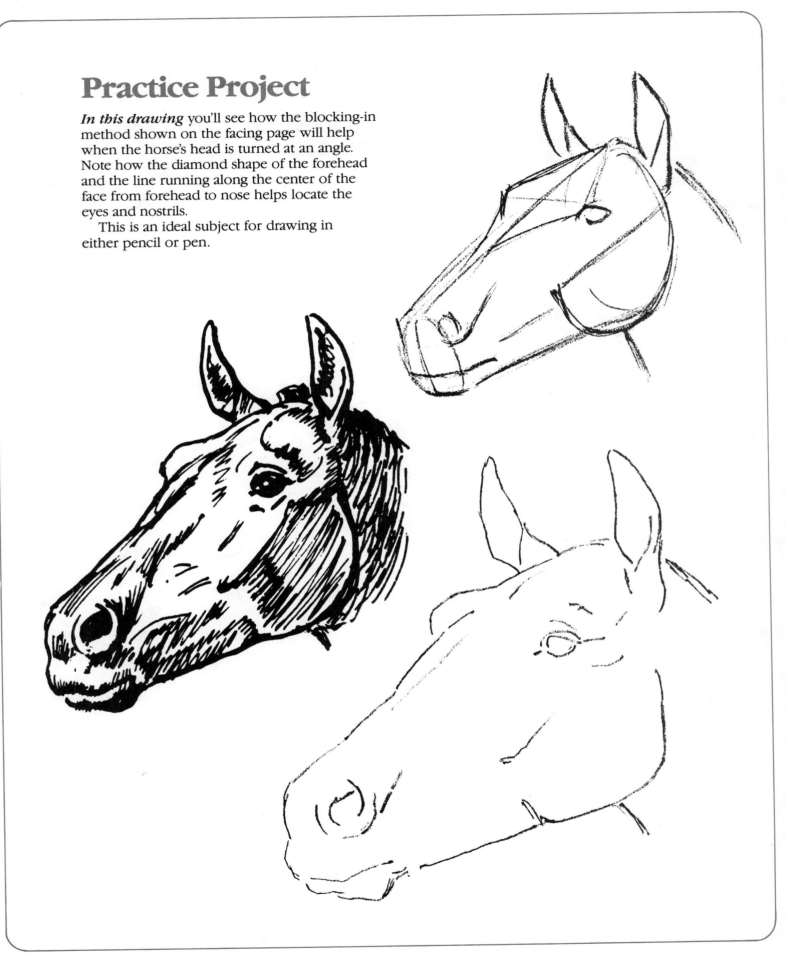

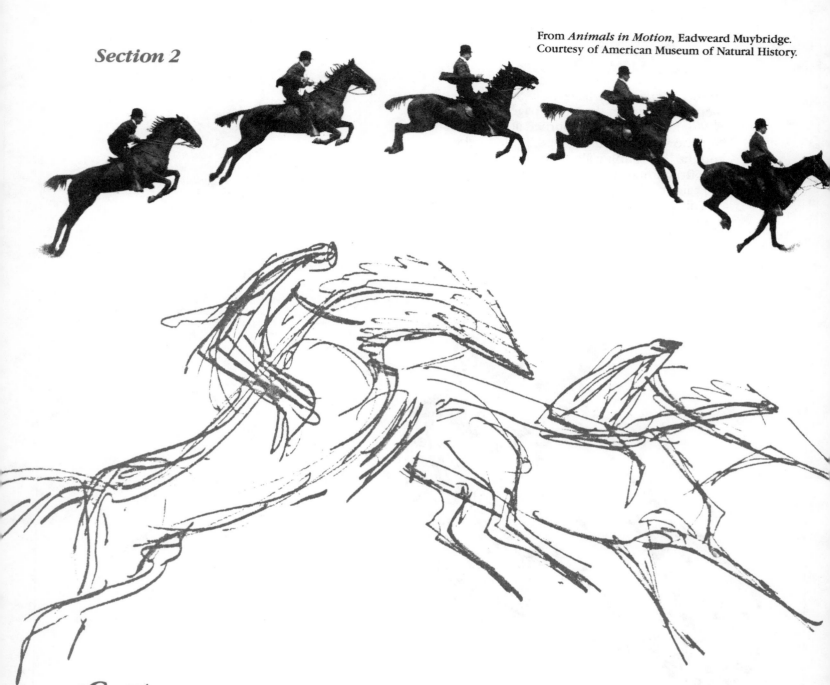

**Section 2**

From *Animals in Motion*, Eadweard Muybridge.
Courtesy of American Museum of Natural History.

# Gesture... *the spirit of the action*

***It's a challenge to try to catch an animal in motion,*** but probably not as hard as you think. On these pages we've demonstrated approaches to action drawing that should make it easier for you.

The best way to get into the rhythm of this kind of drawing is to watch an animal, or a number of them, repeating the same action over and over. All of these drawings were made at a horse show where the artist stood and sketched as fast as he could as the horses took the jump, one after another. Horse shows are made-to-order spectacles for action drawing; so are rodeos and circuses and county fairs. And so are the Westerns you watch on TV.

Let's say that you are at a horse show, just like the artist who did these gesture sketches. You're standing near a jump and the first horse is going over. Start your pencil moving over the paper to catch the gesture, trying to get the feel of the whole jump. You'll probably draw just a line or two the first time, but keep trying with the next jump and the next. After a while your pencil will follow the whole sweep of the action and your drawings will express it as freely and accurately as many of the examples on these pages.

20

Even a grazing horse is constantly on the move. Try to get down the whole pose in a quick sketch like this. As the horse moves, try to record that whole pose, too. Your sketchbook will be quickly filled with many of these variations that will represent its characteristic movements: valuable reference for later use.

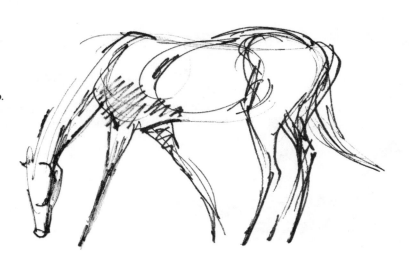

With just a few quick lines, you can capture the direction of the action and shape of the horse. Each time an animal clears the jump you can add more information to your drawing.

## Try these three exercises

### 1. Stop drawing and just look! *Before you start drawing,* spend a few moments just observing the sequence of action and deciding what you are going to draw. And, if you have problems as you go along, put your pencil down for a while and mentally draw the action as you observe it.

### 2. Blind drawing. *Sometimes a change in approach is* helpful. If you don't seem to be able to make your pencil do what you want it to do, try blind drawing. Keep your eyes on the moving animal and, without looking at the paper, let your pencil feel out what you see. Your first attempts may be awful, but this is a good way to learn to coordinate your eye and hand.

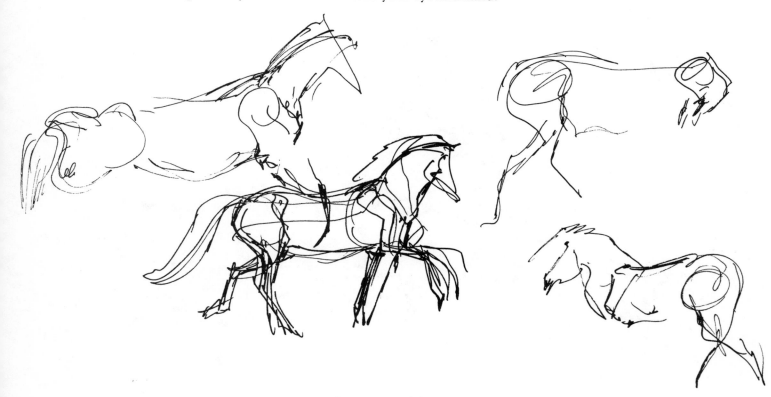

**3. Draw one part at a time.** *A good way to learn to draw a moving animal in more detail* is to focus on one part of him at a time. Assuming that you're still standing near that jump at the horse show, start with the horse's forequarters and keep your eyes on just that part of his body. As one horse follows another over the jump, record what you see happening—just to the forequarters. Work over and over the same sketch, keeping it loose and free. This isn't easy to do—you can see some false starts in the drawing at right, and you're bound to have some, too. But you'll develop the lines with more confidence as you adjust the bend of the neck, the position of the head, the stance of the legs as they hit the ground. Then move on to the midsection and the hindquarters and develop your drawing of them in the same way.

# Practice Project... *gesture drawings*

***These action shots*** are ideal for spirited gesture drawings like those on pages 20 through 23. Fill these pages with sketches, using pencil or pen, and then make other sketches on separate sheets.

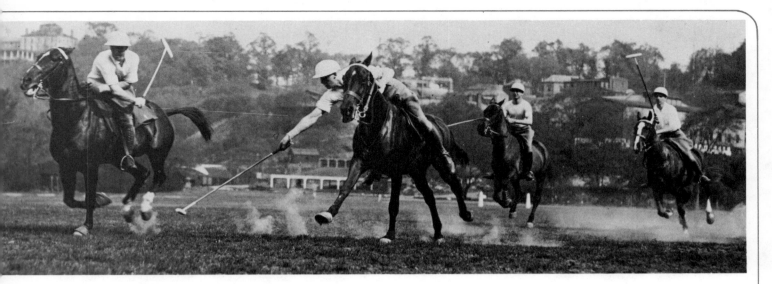

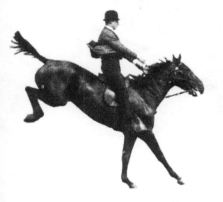

*When you've finished,* turn to the overlay, pages 97 and 98, to see
how a Famous Artists School Instructor interpreted these actions.

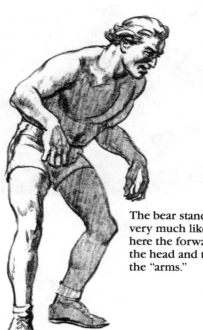

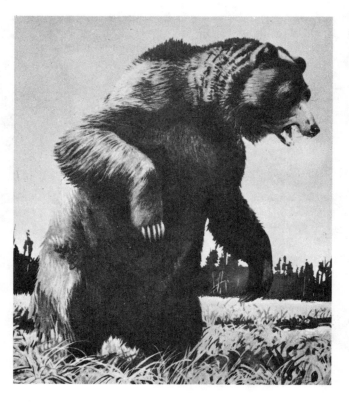

The bear stands and moves very much like a man. Notice here the forward thrust of the head and the action of the "arms."

# Man and Beast—*different yet alike*

***In outward appearance man seems profoundly different*** from the animal, but when we begin to compare them carefully, we see they have much in common. In structure and movement, in behavior and feeling, the human being continually reminds us of the animal.

   This resemblance between man and the animals can be a great help to you in drawing and painting animal subjects.

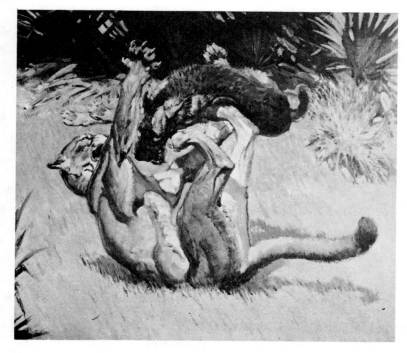

Puma and man also have much in common. Notice particularly the shoulder area and the bone and muscle structure showing in the limbs of both.

# Man is the key to understanding animal structure

*Our first step in learning to draw animals* is to see how they compare with man in physical structure. The parallels are astonishing.

Although most animals stand on all fours, their bone structure is much like man's. Like him they have a skull, backbone, pelvic bone, and legs. Their front legs correspond to his arms.

Even the muscles throughout the animal's body resemble those of the human figure.

To make another comparison clearer, we show the man balanced on his fingers and toes, the way most animals would stand. Look at the joint labeled "wrist" on the front leg of the horse. The portion from this joint to the hoof corresponds to the human hand and fingers. The bones in this area are fused together and the hoof is actually a large "fingernail." Similarly in the rear leg, the section from the "ankle" to the hoof corresponds to the human foot. The resemblances in such areas as the upper arms and upper legs are harder to find because animals have their upper limbs encased in muscles that hold them close to the body.

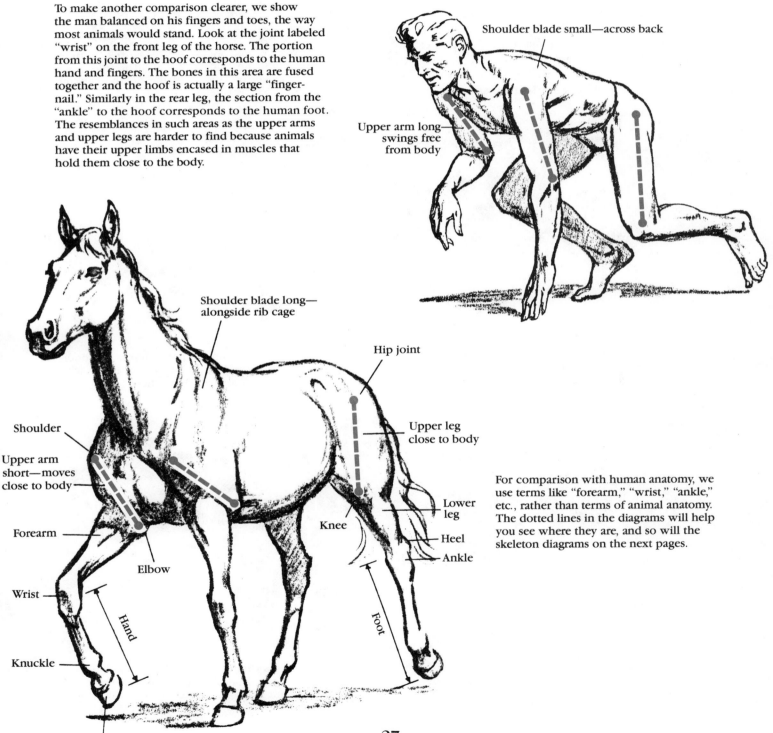

Shoulder blade small—across back

Upper arm long—swings free from body

Shoulder blade long—alongside rib cage

Hip joint

Shoulder

Upper arm short—moves close to body

Forearm

Elbow

Wrist

Hand

Knuckle

Fingernail

Upper leg close to body

Lower leg

Knee

Heel

Ankle

Foot

For comparison with human anatomy, we use terms like "forearm," "wrist," "ankle," etc., rather than terms of animal anatomy. The dotted lines in the diagrams will help you see where they are, and so will the skeleton diagrams on the next pages.

27

# Skeleton...*proportions*

*On the following pages* we are going to take a close look at four animals—the horse, dog, cat, and cow—and see how they compare in basic structure to the human figure. We use these animals because each is representative of many similar types. For example, with slight differences in proportions and size, a cat is similar to a tiger, lion, puma, leopard, jaguar, or bobcat. Such animals as the zebra, deer, and giraffe are built much like the horse. The dog, wolf, and fox are also alike, and so are the cow, bison and water buffalo. By learning these basic animal types, you will gain an understanding that you can apply in drawing virtually any animal. Here you see four basic animals and man. To make them easier to compare, we show them within identical squares.

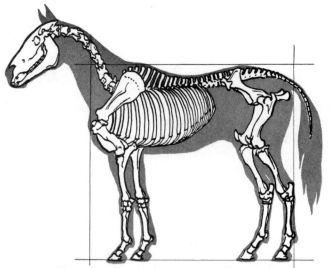

**Horse:** The body of the average horse fits inside a square, with the head, neck, and tail projecting beyond. Compare the bones with those of the man and the other animals here.

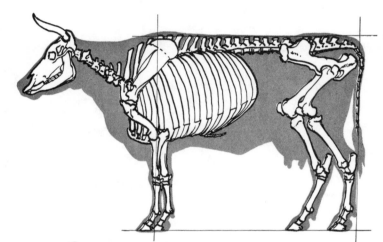

**Cow:** Compared to the horse, the body of the cow is longer in proportion to its legs, and its backbone is quite straight. Notice how the cow's body projects outside the square.

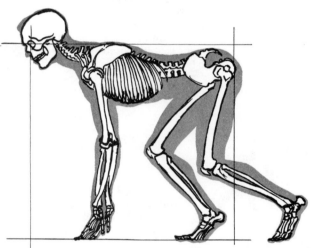

**Man:** The human body is much shorter in proportion to its arms and legs. Compare the bones with those of the four animals shown here.

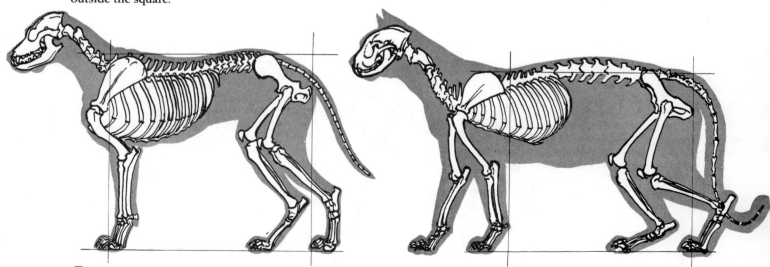

**Dog:** The proportions of the average dog are quite similar to those of the horse. The back legs are normally bent a bit more and the upper bones of the legs are relatively longer than in the horse.

**Cat:** The cat's body is much longer in relation to its legs; its rib cage is small and tapers toward the front; its backbone is long and flexible. Note the typical "crouched" position of the back legs.

# Structure compared

*A good way to understand* the anatomy and structure of the various animal groupings is to begin with one which is familiar to all of us... the horse.

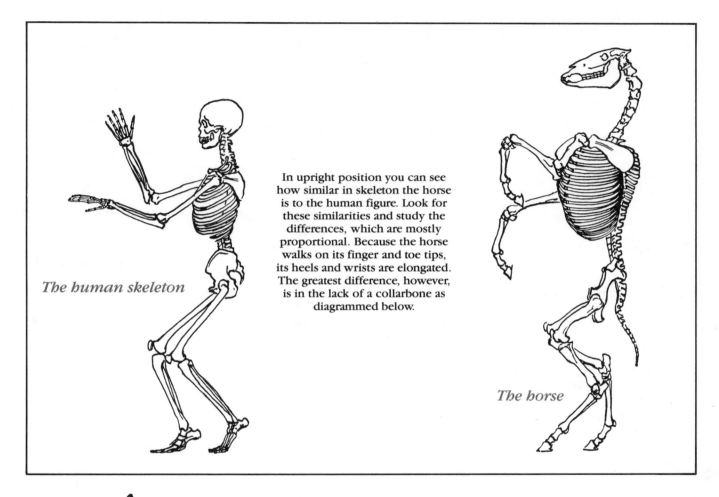

In upright position you can see how similar in skeleton the horse is to the human figure. Look for these similarities and study the differences, which are mostly proportional. Because the horse walks on its finger and toe tips, its heels and wrists are elongated. The greatest difference, however, is in the lack of a collarbone as diagrammed below.

*The human skeleton*

*The horse*

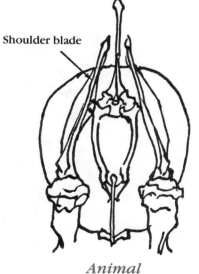

Shoulder blade

Here you see the difference betwen the shoulder region of a man and an animal. A man's rib cage is wide from side to side, and his shoulder blades are across the back of the rib cage. These connect at the shoulder with the curved collarbones, which reach around to the breastbone in front. *The typical animal has no collarbone.* Its rib cage is narrow from side to side, and its shoulder blades are placed along the sides of the upper rib cage.

*Animal*

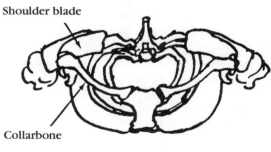

Shoulder blade

Collarbone

*Man*

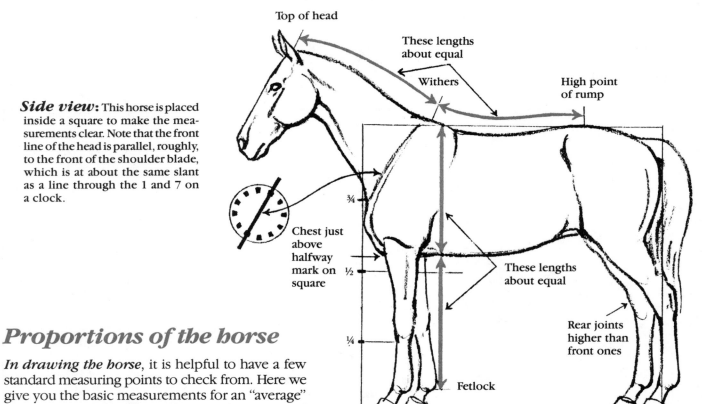

Top of head

These lengths about equal

Withers

High point of rump

**Side view:** This horse is placed inside a square to make the measurements clear. Note that the front line of the head is parallel, roughly, to the front of the shoulder blade, which is at about the same slant as a line through the 1 and 7 on a clock.

¾

Chest just above halfway mark on square

½

These lengths about equal

¼

Rear joints higher than front ones

Fetlock

## Proportions of the horse

**In drawing the horse,** it is helpful to have a few standard measuring points to check from. Here we give you the basic measurements for an "average" horse. Most of the horses in your drawings and paintings will have proportions like this. You can easily make the necessary changes for other horses such as the heavily proportioned draft horse or the Arabian, which has a shorter backbone.

Naturally, when the horse is turned to other positions or is in action, you will have to estimate the measurements and the foreshortening.

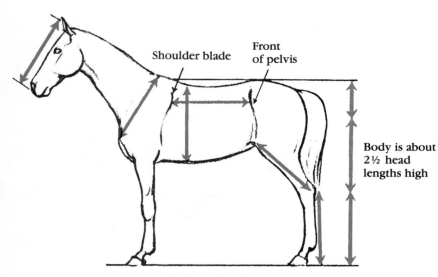

Shoulder blade

Front of pelvis

Body is about 2½ head lengths high

You can use the length of the head to check the measurements shown here (arrowed lines equal one head length).

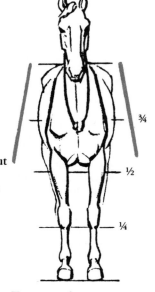

¾

½

¼

**Front view:** The heavy lines emphasize the characteristic slope of the shoulder blades.

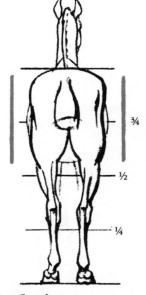

¾

½

¼

**Back view:** Here you can see the squarish shape of the shoulder blades.

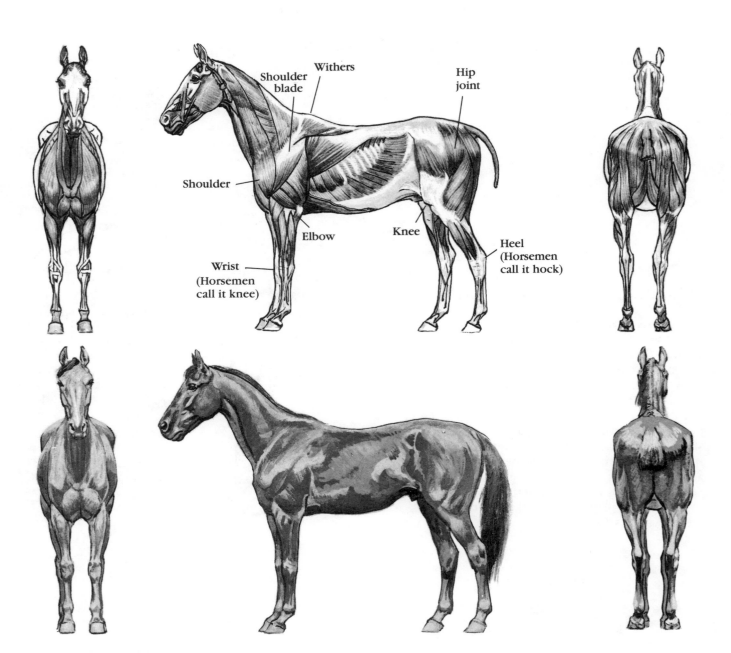

# The Horse...

## *Muscles that show on the surface*

***Right on the surface of the horse*** you can see the hardness of the bone and the bulge of the muscle underneath. Before you can draw these forms, however, you must recognize them. In the top row you see the actual structure of the muscles, and in the second row how they appear on the surface. As you study this page, turn back to page 28 so you can see the position of the bones in relation to the muscles.

Draw the muscles only as they actually appear on the surface. Your goal is not to create an illustration for an anatomy text, but a good, lifelike picture.

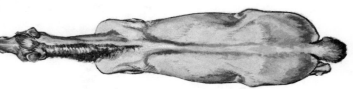

The bony framework of spine, shoulder blades, and hipbones is very prominent when we view the horse from above.

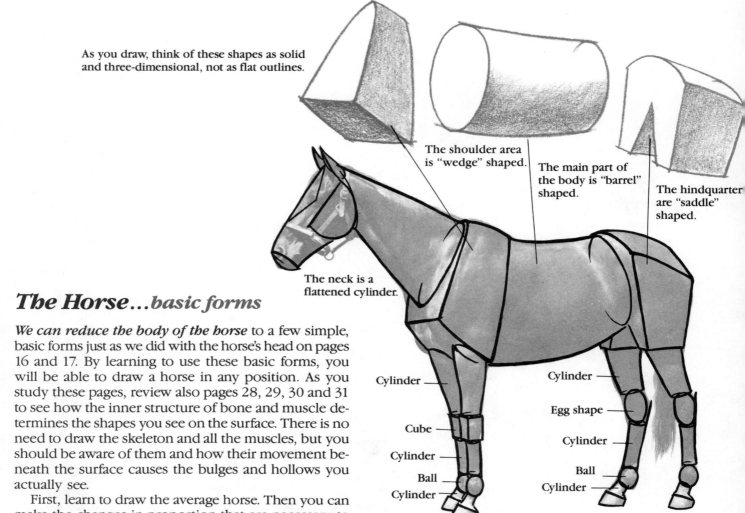

As you draw, think of these shapes as solid and three-dimensional, not as flat outlines.

The shoulder area is "wedge" shaped.

The main part of the body is "barrel" shaped.

The hindquarter are "saddle" shaped.

The neck is a flattened cylinder.

Cylinder

Cube

Cylinder

Ball

Cylinder

Cylinder

Egg shape

Cylinder

Ball

Cylinder

## *The Horse...basic forms*

*We can reduce the body of the horse* to a few simple, basic forms just as we did with the horse's head on pages 16 and 17. By learning to use these basic forms, you will be able to draw a horse in any position. As you study these pages, review also pages 28, 29, 30 and 31 to see how the inner structure of bone and muscle determines the shapes you see on the surface. There is no need to draw the skeleton and all the muscles, but you should be aware of them and how their movement beneath the surface causes the bulges and hollows you actually see.

First, learn to draw the average horse. Then you can make the changes in proportion that are necessary to depict various types.

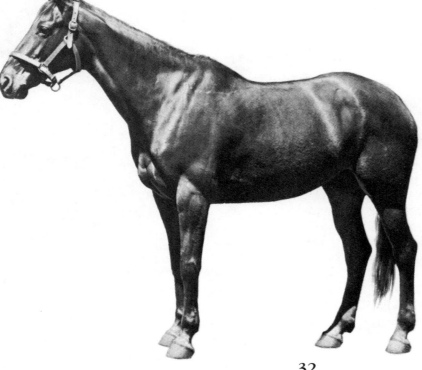

Study these diagrams carefully and learn to draw these basic forms from all angles. Remember to draw through so that they fit together properly.

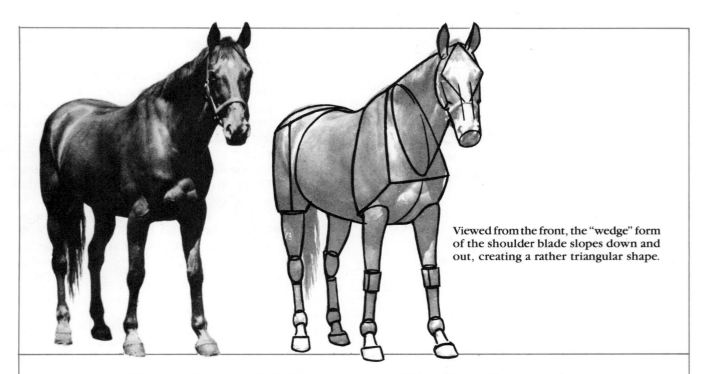

Viewed from the front, the "wedge" form of the shoulder blade slopes down and out, creating a rather triangular shape.

*After you have studied this section*, you will be able to observe and understand animals much better, whether you are sketching them from life or from photos. You will not have to find the exact position to copy, but will be able to visualize and construct animals in different positions.

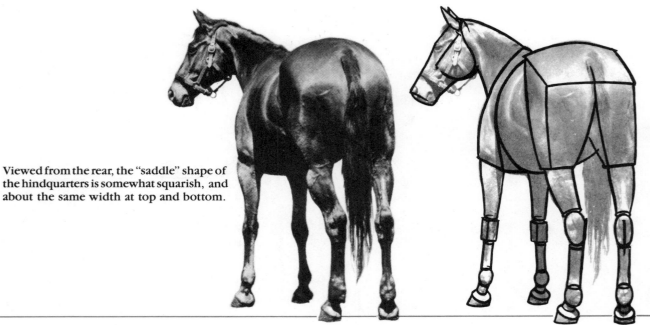

Viewed from the rear, the "saddle" shape of the hindquarters is somewhat squarish, and about the same width at top and bottom.

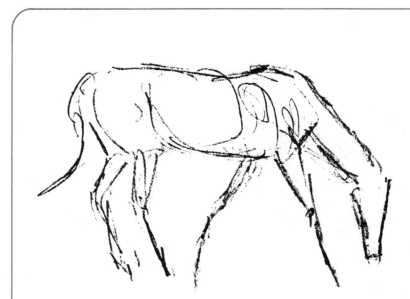

# Practice Project...
## *basic form drawings*

***Making a gesture sketch*** is a good way to start drawing an animal. For this Practice Project, you are to build up the basic forms of these horses, using the method shown on the previous two pages. You may draw directly over these gesture sketches or use the tracing paper method shown on page 96. If you prefer, you can make your own sketches off to one side or on a separate piece of paper. Don't make finished drawings—just basic forms.

When you've finished, tear out the overlays, pages 99 and 100, so you can compare your work with that of an Instructor.

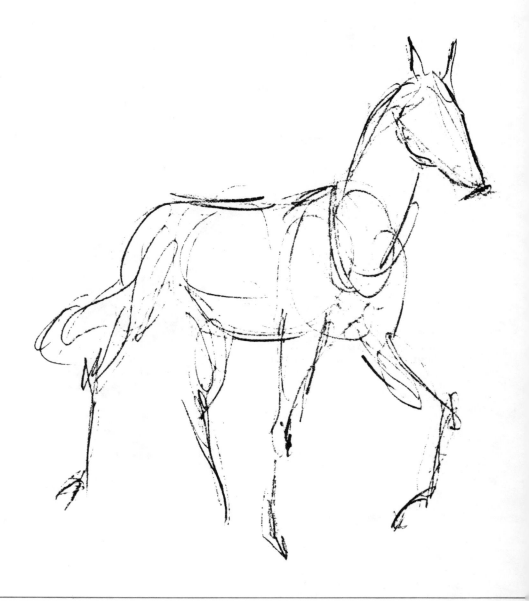

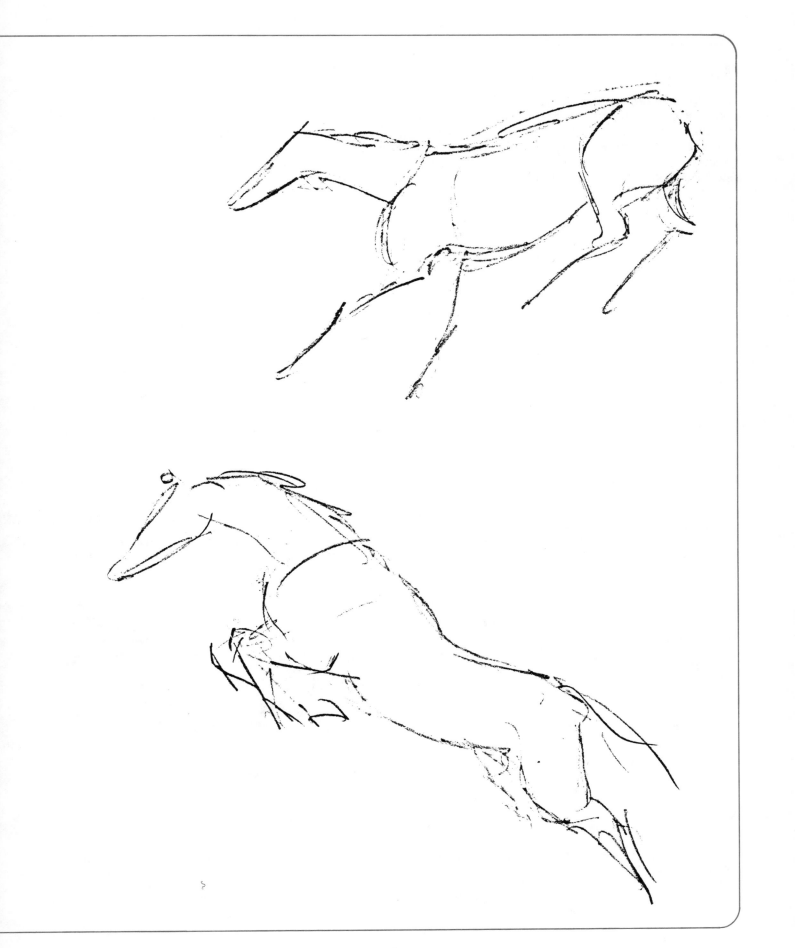

# How to draw the horse... *step by step*

*By now you have acquired quite a lot of information* about horses. We are going to apply that knowledge to a step-by-step procedure which you can use to draw horses in any position, whether from life or from photos. Gesture drawings you have made will provide an excellent beginning. You may find it helpful to develop these successive steps using the tracing paper method described on page 96. Here let us assume that you have chosen a side view of a simple walking position.

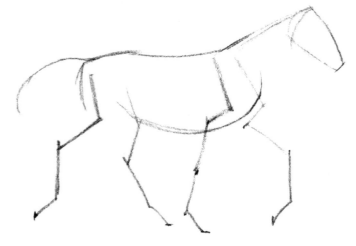

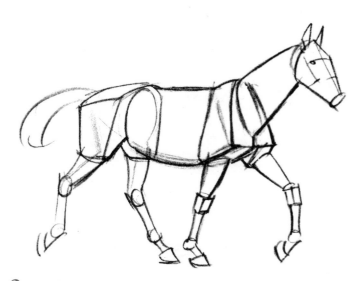

*1.* Sketch lightly a line running along the top of the neck and body, and indicate the bottom of the barrel-shaped body. Then, keeping the skeleton structure in mind, indicate the position of the legs and shoulder blades, and the long tapering head.

*2.* Using the basic shapes previously shown, start building solid forms. Draw through to make them fit together properly. Use the proportional checks shown on page 30 to be sure that the parts of the body are the right size in relation to each other.

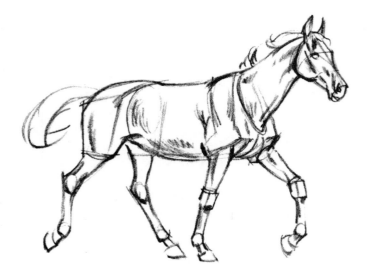

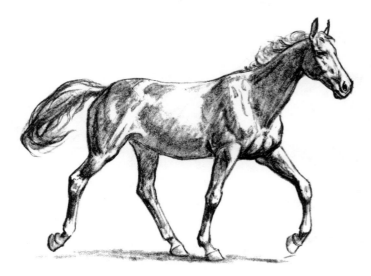

*3.* When you have finished blocking in the "basic form" horse, start indicating the realistic shapes caused by the muscles and bones. (See muscle diagram on page 31.) As you do this, emphasize the rhythmic flow of action throughout the body. Draw the head as shown on page 17.

*4.* Finish by erasing unwanted construction lines and putting in modeling. As you model, think of the bones and muscles beneath. Notice particularly the places where the bone is near the surface, such as the shoulder and the leg joints.

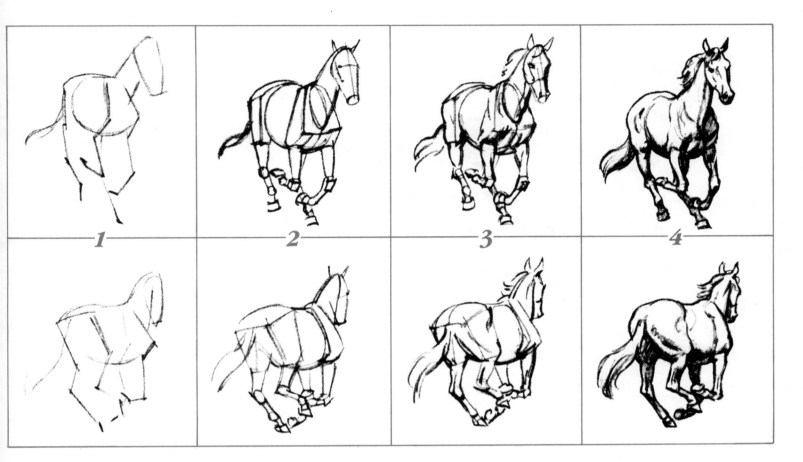

*In sketching the front and rear views of the running horse*, it is important to draw through carefully to solve the problems of overlapping forms and foreshortened parts of the body, legs and neck. Just as in the demonstration above, you should first establish the general position and action and then draw the forms. It is often a helpful practice to use a photo as a basis for the horse's pose. To analyze the action, place a piece of tracing paper over it. Then, observing the photo beneath, you can superimpose a basic form drawing to capture the pose.

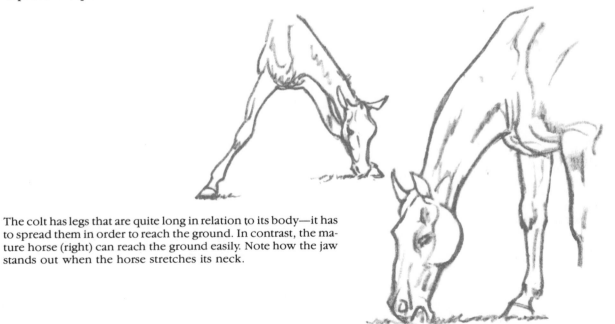

The colt has legs that are quite long in relation to its body—it has to spread them in order to reach the ground. In contrast, the mature horse (right) can reach the ground easily. Note how the jaw stands out when the horse stretches its neck.

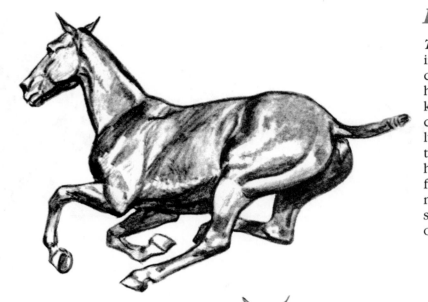

## How the horse moves

*There is beautiful form and rhythm* in the movement of the horse. To understand this movement and draw the horse in convincing action, you must know how the upper legs and the shoulder blades move. The diagrams here illustrate this. Always keep in mind that the horse's legs swing from pivot points high up on its body. The front legs swing from the top of the shoulder blades up near the withers, and the back legs swing from the hip joint near the top of the hindquarters.

Study this position carefully and you will see that the near shoulder has swung forward and the elbow forward and down. The back legs have swung forward from the hip joints, also.

To illustrate dramatically the pivot points from which the legs swing, we've drawn an imaginary pole through these points of support. Observe how freely the legs and the shoulder blades can move from these points.

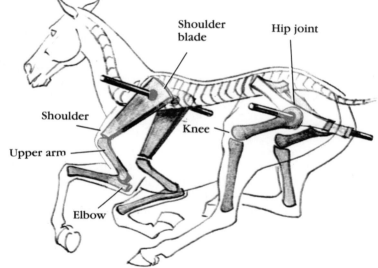

In these pages we give you a logical method of drawing animals, but nothing can take the place of careful observation. Draw from living animals whenever possible. Build up a good collection of photos or pictures you clip from magazines to use as reference, and study the action of animals you see on your TV screen.

In violent actions like this the basic forms do not stay rigid. The wedge-shaped shoulder area moves in two separate parts, and even the saddle-shaped hindquarters twist as the legs move alternately forward and back.

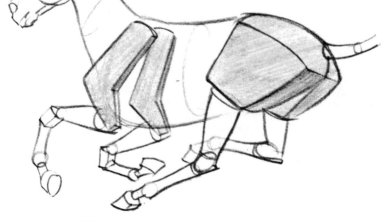

38

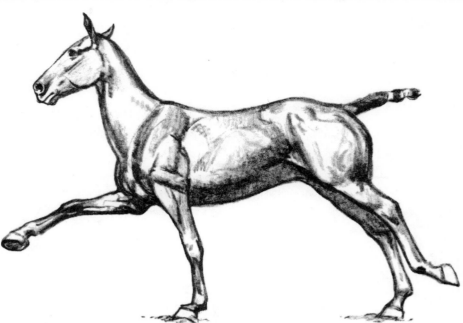

*Just as a man's right leg and left arm* move forward at the same time to insure balance, so do the legs of a horse in walking. When a horse is moving forward with his forefoot during a stride in the gallop, he raises his forequarters and drops his head slightly. When he reaches forward with his rear feet, the hindquarters are higher than the forequarters and to maintain balance, the head is slightly raised.

In this view, the animal's shoulder and elbow on the near side have swung back, while the shoulder and elbow of the far side have swung forward. The entire hindquarters have swung up and back.

Upper leg

Upper arm

This analysis of the illustration above shows how the legs swing from pivot points in this position. The movements of these bones are disguised to some extent by the mass of muscles and outer flesh covering them.

Compare the positions of the basic forms in this view with those at the left and see how they change. These forms not only suggest the movements of the animal's hidden bones and muscles, but can easily be developed into a finished drawing.

39

To show the gait sequence clearly, the legs touching the ground are darkened.

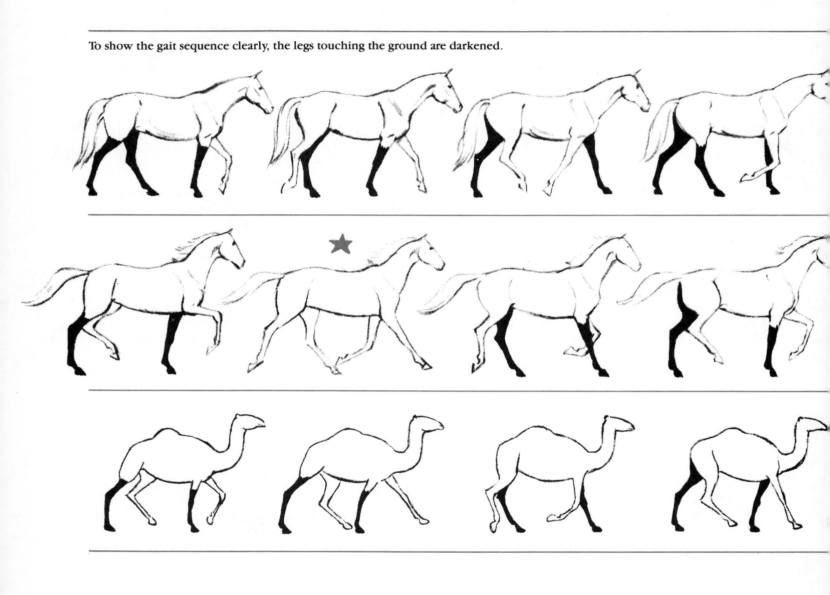

The backbone bends to allow the rear legs to move forward. Notice how this changes the outline of the top of the hindquarters. Observe, too, how the shoulder area moves forward and back with the front legs.

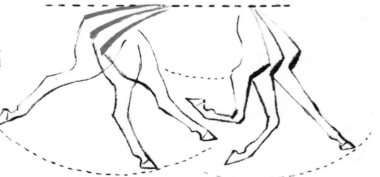

*When a horse walks, trots, or runs*, its feet touch the ground in definite sequences. These movements are called gaits. Most of these gaits are the same for all animals, but there are some exceptions. On these two pages we show you the basic gaits and explain the differences where they occur.

In the gaits pictured on this page—the walk, trot, and rack—all of the animals touch the ground with their feet in similar sequences. The gallop, however, varies with different animals. There are two different gallops, the diagonal and the rotary, shown on pages 42 and 43.

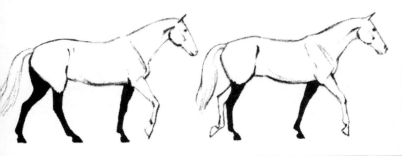

*Walk:* In this action there are always two or three feet on the ground at the same time. If you will compare the movement of the front and back legs, you will see that the front leg moves forward and touches the ground just a moment after the back leg on the same side.

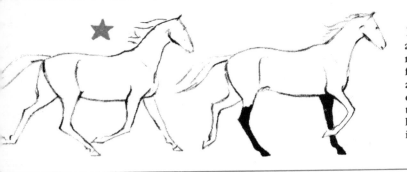

*Trot:* In the trot, the animal lifts and moves the diagonal feet at the same time. Note the way the right rear and left front feet move forward or back at the same time, and the left rear and right front move together. Twice during each full stride all four feet are off the ground. These positions are marked with a star. The distance the feet are lifted from the ground varies. Sometimes they are merely dragged, while at others they are proudly lifted high. Just remember the simple rule—contact with the ground is made with the two diagonal feet.

*Pace or rack:* In this movement the front and rear legs on the right side move forward at the same time. Similarly, the front and rear legs on the left side move at the same time. This gait is natural to the camel and the giraffe. The horse has to be trained to pace for harness racing.

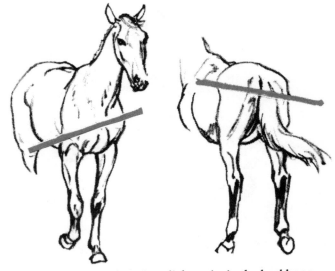

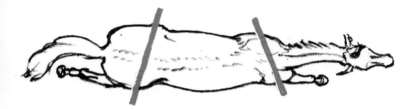

*Body movement:* Although the horse's body is a solid mass, it is not rigid. These diagrams show some important places to watch for movement.

As the horse's legs move, there is a slight twist in the backbone and the shoulders slide forward and back. The hindquarters also twist.

As the horse shifts its weight from one leg to the other, its hips and shoulders move up and down accordingly just as in the human figure.

41

# The gallop and leap

*The diagonal gallop is a "cross" gallop.* When the action starts with the left rear foot, the next foot striking the ground would be the right rear, then the left front, and finally the right front. The movement can also start with the right rear foot. The sequence then would be right rear, left rear, right front, and then left front. There is a point in this gait when all the legs are under the body at one time, and none of them is in contact with the ground. The diagonal gallop is used by the horse, cow, goat, hog, camel, and many other animals.

*The rotary gallop is a "round" gallop.* The simplest explanation of this kind of gallop is that the successive feet striking the ground go either clockwise or counterclockwise. For example, if the animal starts with the right rear foot touching the ground, it would then put down the left rear, left front, and right front in succession. The rotary gallop is used by the dog, deer, antelope, elk, and a few other animals.

As an animal gallops, the legs are alternately stretched out and tucked under the body. There is also a typical rocking motion. At the time the two forefeet are in contact with the ground, the rear of the body is higher than the front, giving the body an overall forward slant. At the moment the body is being thrust forward from the hind feet, the opposite slant occurs.

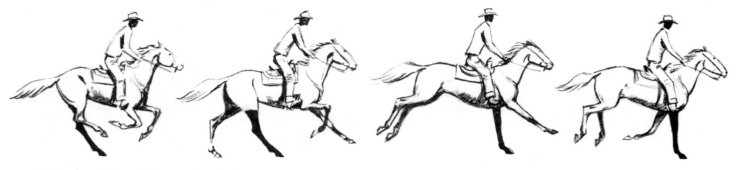

***Diagonal gallop:*** Here the gallop starts with the left rear foot. The next foot to touch is the right rear, then across to the left front and last, the right front as shown by the darkened legs. The diagram below also illustrates this sequence.

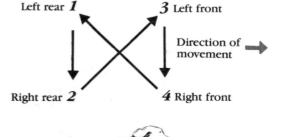

Left rear **1**          **3** Left front

Direction of movement →

Right rear **2**          **4** Right front

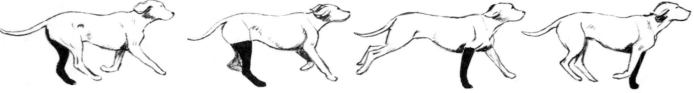

***Rotary gallop:*** In the gallop shown here the legs move counterclockwise. The order is: left rear—right rear—right front—left front. The legs can also move clockwise.

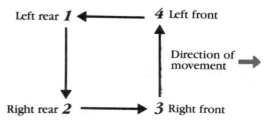

Left rear **1** ←      **4** Left front

Direction of movement →

Right rear **2** →      **3** Right front

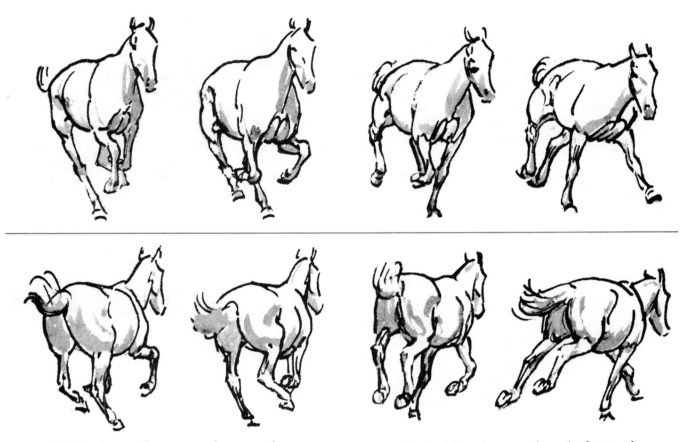

*Galloping—front and rear views:* These drawings of galloping actions seen from the front and rear show positions useful for the artist. Note how the head moves up and down with the different leg positions. When the legs are drawn together under the body, the head is high—when they are extended, it is low. (The positions are not in sequence.)

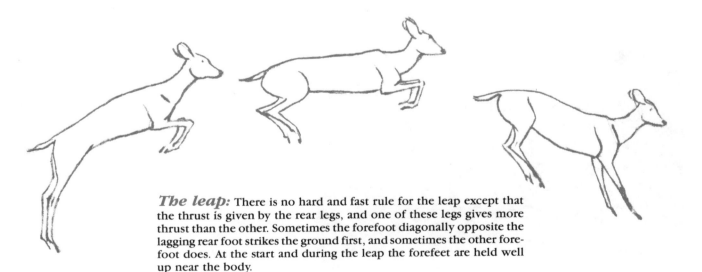

*The leap:* There is no hard and fast rule for the leap except that the thrust is given by the rear legs, and one of these legs gives more thrust than the other. Sometimes the forefoot diagonally opposite the lagging rear foot strikes the ground first, and sometimes the other forefoot does. At the start and during the leap the forefeet are held well up near the body.

# Practice Project

*In action or at rest*, the horse is always a pleasure—and a challenge—to draw! These pages give you a chance to do finished drawings using all you've learned. After studying the gesture and basic form sketches to help you understand the action, make drawings of these horses (with or without the riders). When you've finished, tear out the Instructor Overlay, pages 101 and 102, and study the helpful suggestions.

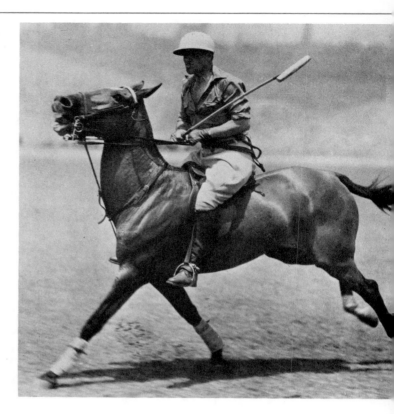

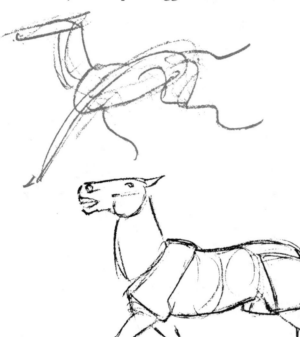

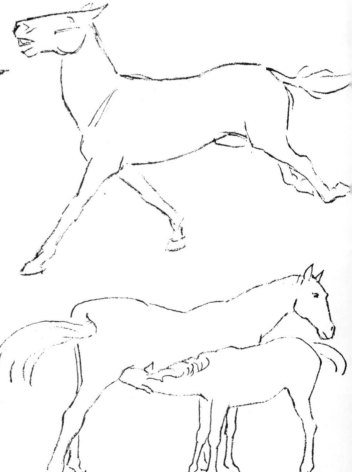

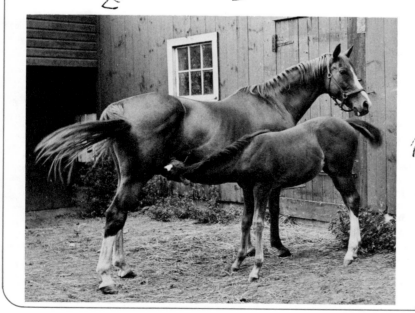

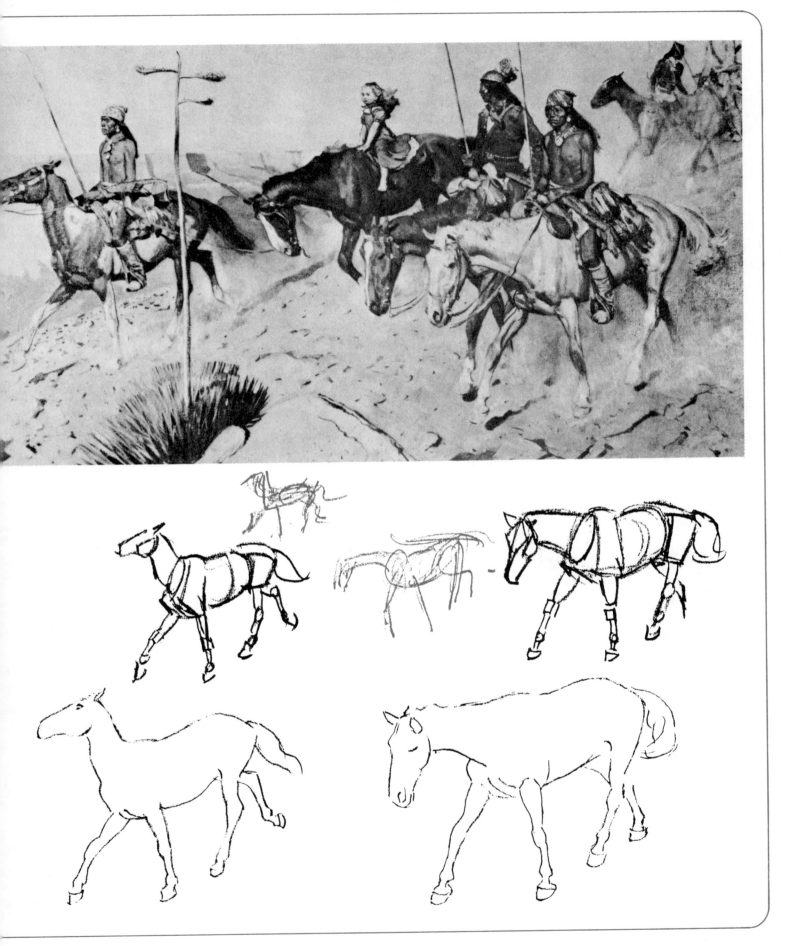

# The Dog...
### *muscles that show on the surface*

*You can easily see this dog's muscle structure* on the surface of its body. Study the top and bottom rows of drawings below and note how certain muscle forms show through the skin. Check these drawings with the skeleton structure on page 28. As you do this, notice how clearly the rib cage shows on the surface and how, in the view from above, the forms caused by the shoulder blades stand out. These are especially important points to look for when drawing a short-haired dog like this.

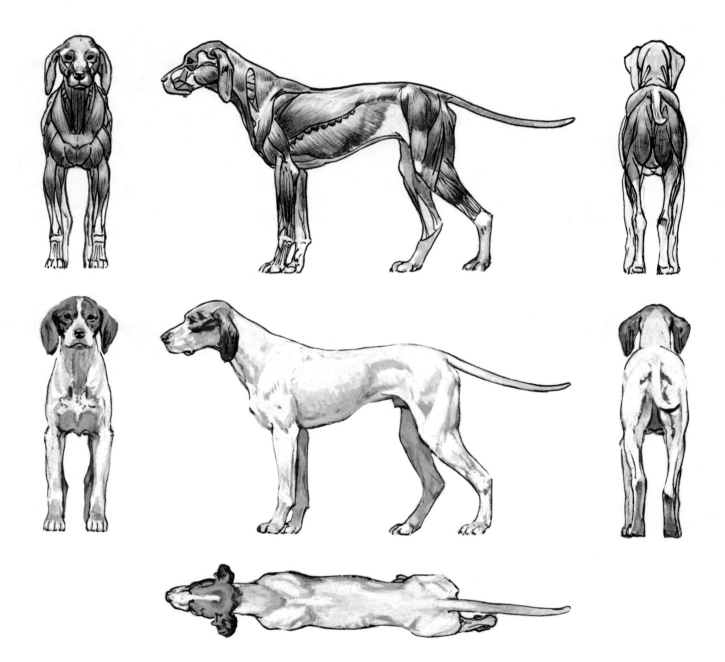

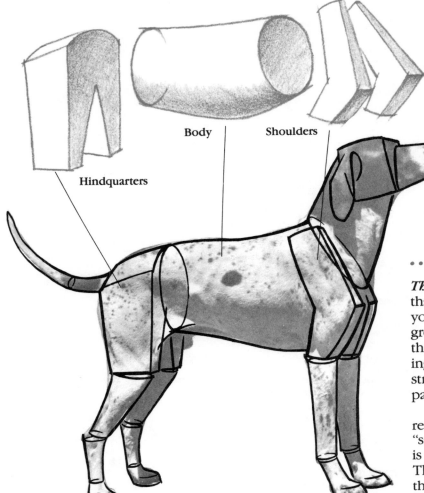

Hindquarters

Body

Shoulders

## ...basic forms

**The dog is so much smaller than the horse** that it seems a very different animal, but what you have learned about the one will help you greatly in drawing the other. In basic structure the two are much alike, the main difference being in the proportion of the leg bones and the structure of the feet. Look at the diagrams on page 28 and you will quickly see this.

Above, we have taken an "average" dog and reduced it to its basic forms. Notice that the "saddle" shape representing the hindquarters is a little longer and thinner than in the horse. This is because the dog's "knee" is well below the body.

**Of course there are all kinds and types of dogs.** Some have long legs, some have short. Some have long, pointed noses; others, like the bulldog, have almost flat ones. The basic structure is the same, however. In some dogs this structure is easy to see, in others less so. In a collie, for example, much of the form is hidden by the long hair. But you must understand this solid form to draw the dog properly, or it will look like a shapeless ball of fur. Always analyze the structure before you draw.

# How to Draw the Dog

## ...step by step

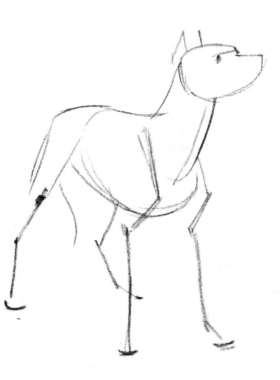

1. Working freely, lightly suggest the general size and position of the dog. Indicate the action of leg bones and shoulder blades.

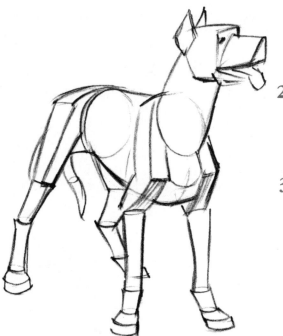

2. Now block in the basic forms. Draw through to be sure that the parts fit together correctly.

3. Keeping in mind the bone and muscle structure beneath, add surface detail, but do not lose the large, solid form.

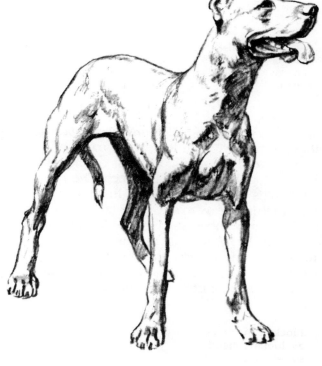

### The Ear

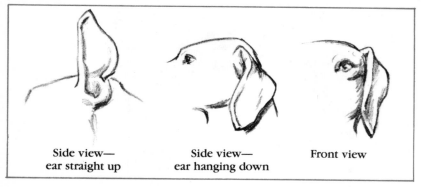

Side view—
ear straight up

Side view—
ear hanging down

Front view

48

# Drawing the dog's head

**The dog is one of the most expressive of animals.** Its face shows every emotion clearly, and its body gesture or attitude emphasizes the emotion. This makes the dog an ideal "ham" actor, and a useful character in many pictures.

There is no special problem in simplifying the dog's head to its basic forms. These forms vary with different breeds, but once you have learned to draw the general shape you can easily make the necessary adjustments.

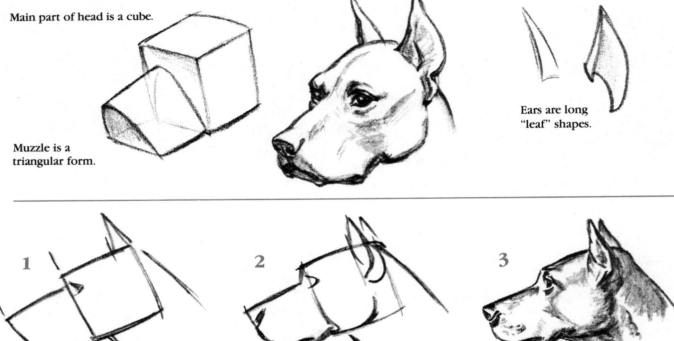

Main part of head is a cube.

Muzzle is a triangular form.

Ears are long "leaf" shapes.

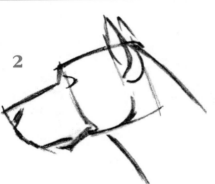

**1**

Sketch the two main portions of the head. (Note the "step down" in front of the eye.) Show the neck at a slant as shown.

**2**

One-third from the back of the skull to the eye locates the back of the jawbone. The ear fits on just behind this.

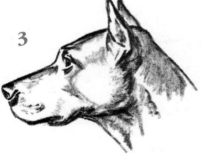

**3**

Add details, but don't lose the solid forms. Show the eye and eye socket curving around in front of the cranium.

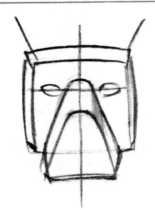

Block in the two basic forms. Here we are looking slightly down on the head, so we can see the top planes.

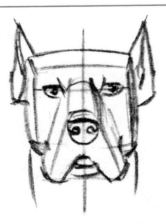

Indicate the nostrils and mouth inside the front triangular shape. Notice how the lips slant down and out.

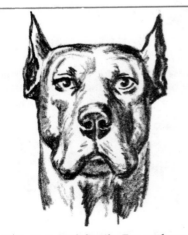

Add texture and details. Eye sockets are indicated by the suggestion of the bones of the forehead and cheek.

# Gaits of the dog

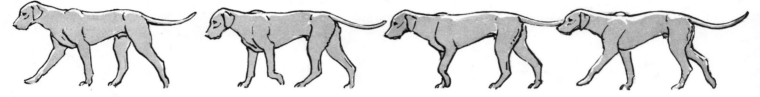

**Walk:** Note that the front leg touches the ground just a little after the corresponding back leg does.

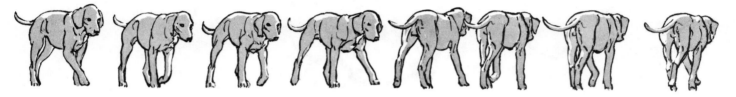

*Walk—front view*          *Walk—rear view*

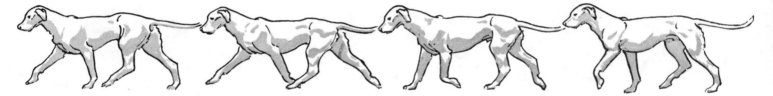

**Trot:** Just as with the horse, the dog's right front leg moves forward at the same time as its left rear leg, and its left front leg moves forward at the same time as its right rear.

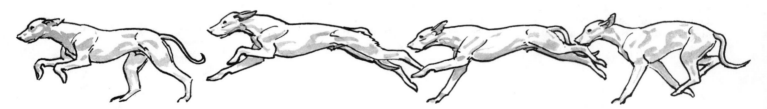

**Gallop:** The dog uses the rotary gallop as described on page 42. Here you can see how in some positions all four feet are beneath the body, and in other positions all four feet are extended.

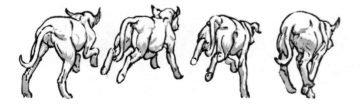

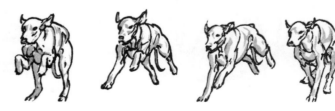

*Gallop—rear view*          *Gallop—front view*

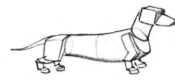

The same forms but different proportions and you have a dachshund.

With the basic forms you can draw any type of dog —in any position.

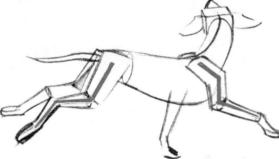

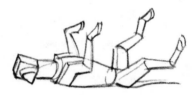

Unusual positions are easily drawn with the basic forms.

Sketch the basic forms first to get construction and action—then draw the surface shapes, hair, etc.

## How to use the basic forms

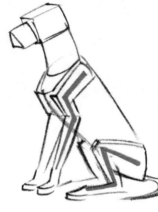

The leg bones of the dog have a zig-zag direction. Notice particularly the extended rear legs of the running dog and the folded-up rear legs of the sitting dog.

# Draw from life—every chance you get

*Dogs are usually readily available to sketch from.* Make it a habit to study and sketch their actions. As you do so, think of the positions of the shoulder blades, leg bones, rib cage, etc. Don't merely draw a cold, mechanically constructed animal, however. Try for the *spirit of the action*. Notice the strong feeling of life and animal personality in these drawings by Harold Von Schmidt.

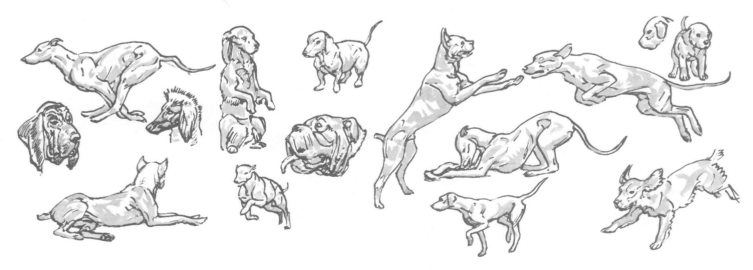

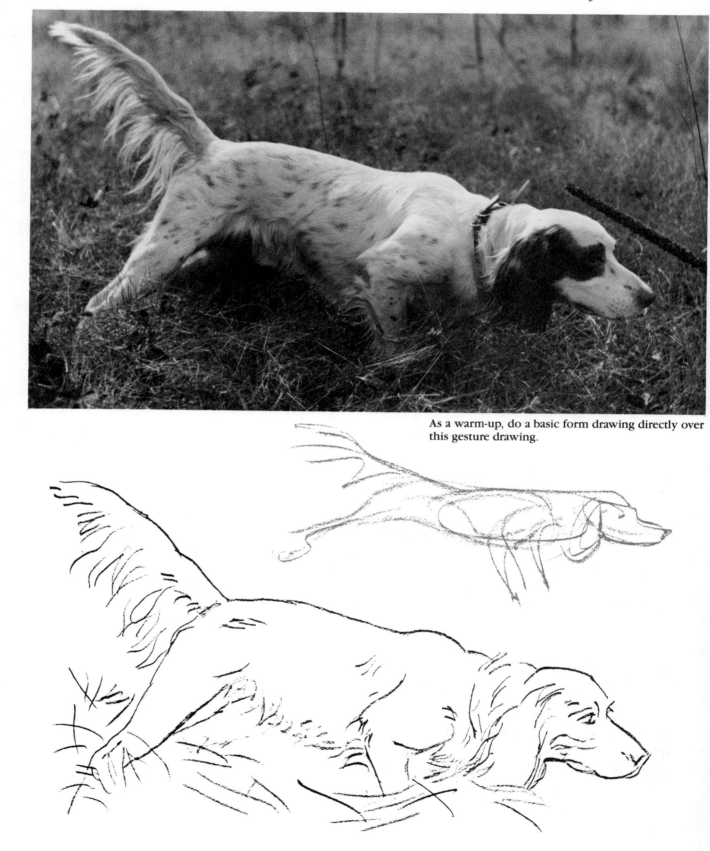

As a warm-up, do a basic form drawing directly over this gesture drawing.

***Before drawing these dogs***, carefully review pages 46 through 51. We are sure this study will give you a new appreciation of the structure and personality of this wonderful animal. As you draw, keep in mind the positions of the shoulder blades and leg bones, as diagrammed on page 51. Remove page 103, to compare your drawings with those on the Instructor Overlay.

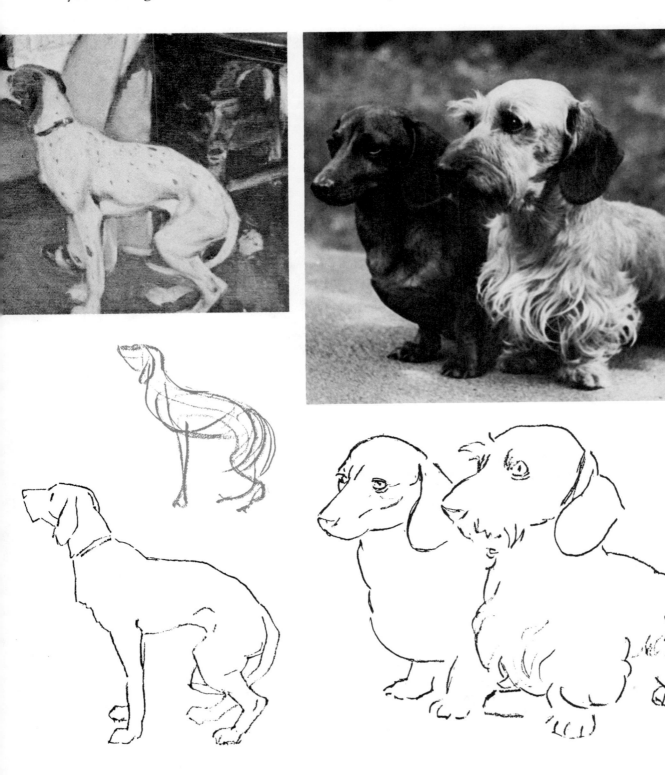

# The Cat...

## *muscles beneath the skin*

*These drawings show you how the muscle structure* affects the appearance of the cat. As you study the muscles, look at page 28, where the proportions of the skeleton are analyzed. Observe how the structure of bone and muscle creates curves and sharp angles in the mobile form of the animal.

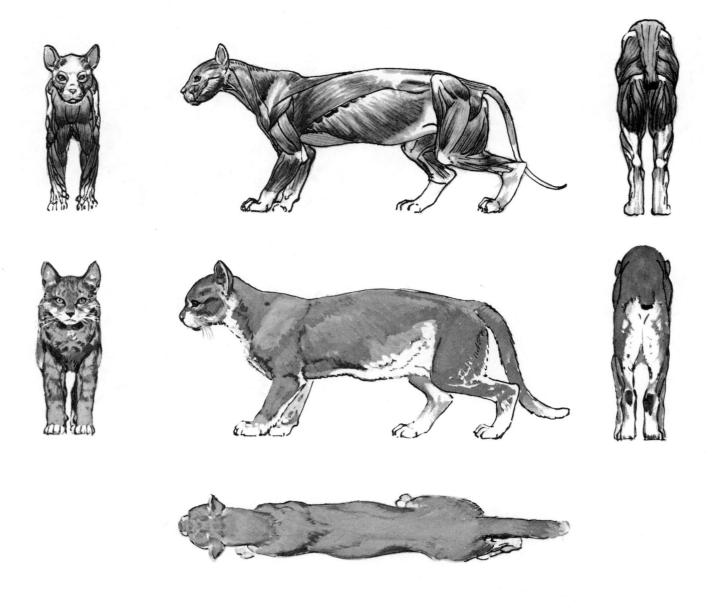

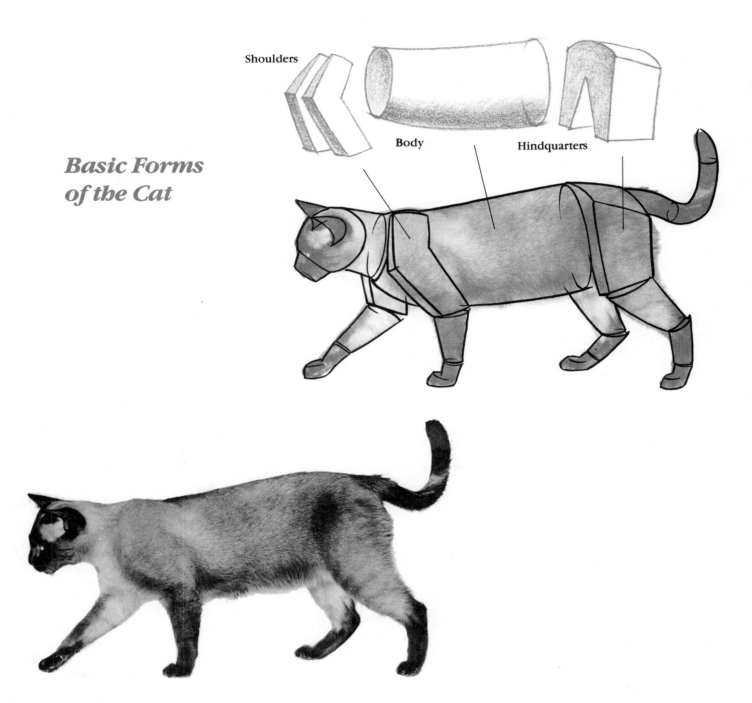

## Basic Forms of the Cat

Shoulders

Body

Hindquarters

***The cat is a born climber and leaper.*** As it moves, there is a flow of action that runs through its entire body, giving it a special gracefulness that marks the whole cat family.

The basic forms used in learning to draw the cat are similar to those of the horse and dog, but *different in proportion*. The cat's head is *small* and the body *long*. The bottom line of the body goes almost straight back from its small rib cage. This differs markedly from the dog which has the deep chest of a long-distance runner, as you can see on page 46.

There are some interesting differences, too, in the heads of the cat and the dog. The average dog's jaws and nose project in the form of a well-defined muzzle. The cat's muzzle, by contrast, is *quite short*. The dog detects its prey chiefly by smell and its long nose is a useful adaptation for this purpose. The cat, however, hunts mainly by sight. For its size, it has the largest eyes of all the meat-eating or carnivorous animals. The pupils are narrow slits in bright light, but at night they open wide to admit as much light as possible and help the animal to see.

**1.** Sketch a curved line representing the top of the neck, body, and tail. Indicate the action of the leg bones and shoulder blades, and the bottom line of the body.

# How to Draw the Cat
## ... *step by step*

**2.** Block in the basic forms. Notice that the front leg starts its action at the top of the shoulder blade, and this entire form moves as a unit.

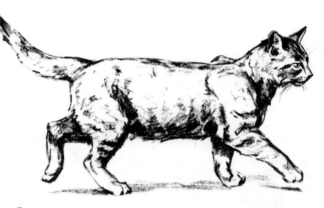

This foreshortened pose demonstrates how to use the basic forms. The center line over the cat's head and along her back helps relate all of the parts of the body in a smooth, graceful action. The mother's shoulders move forward along her neck while the kitten's hang down along its body.

**3.** Now add the surface detail and shading. Retain the feeling of the solid structure underneath even when you are drawing a cat with long hair.

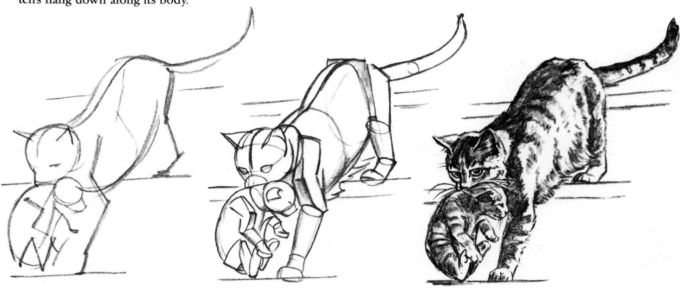

56

## Drawing the cat's head

**Many artists have found the head of the cat,** with its strange eyes, intense, brooding, or sleepy—a fascinating subject to draw. We can reduce this head to a ball, longer and wider than it is high, with a small, tapering cylinder in front, containing the nose and mouth. The eyes are much nearer the nose than in most other animals. The triangular ears are on the back third of the head.

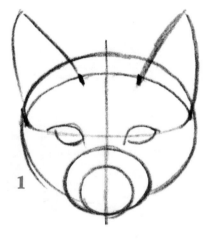

Draw the ball and cylinder. Just above the cylinder, sketch a curved guide line to locate the eyes and the bottom corners of the ears, which are about one ear-width apart.

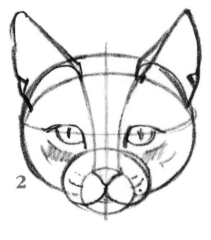

Sketch the nose, mouth, and chin. Curved lines run up from the nose and flow smoothly into the outline of the ears. Notice the divided upper lip. Indicate notch on side of each ear.

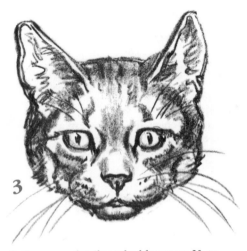

Refine your details and add texture. Note the shape of the pupils and that the whiskers grow in rows—not haphazardly. The ears, of course, can move to different positions.

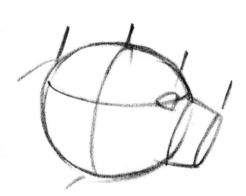

Sketch in the basic forms. On a horizontal guide line about a third down from the top of the ball we locate the eye, which is about one-third from the nose to the back of the head.

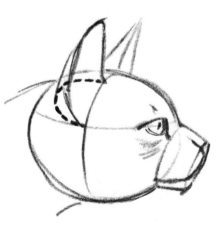

"Draw through" the base of the ear, shown here as a dotted half-circle. Note how the neck joins high on the back of the head, forming a smooth curve with the top.

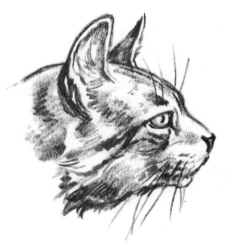

Add the surface detail and texture. Be sure not to draw the eye flat on the side of the head. It curves around toward the front of the face. Note the prominent hairs over the eye.

## Basic forms in action

*These basic form drawings show how our method of blocking in can be used to draw cats in any action. Notice that the forms act together to create an overall movement throughout the body.*

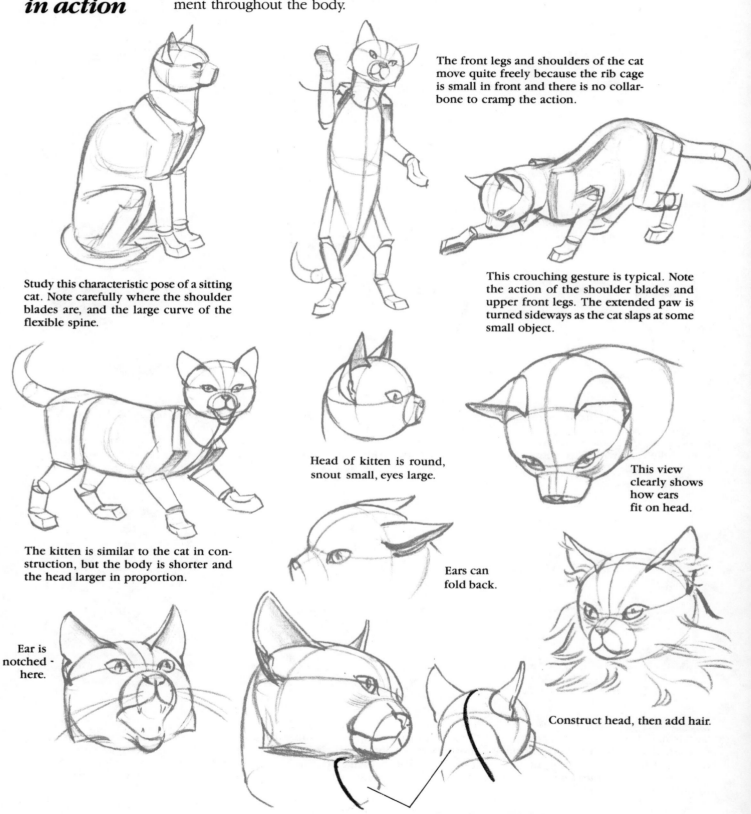

The front legs and shoulders of the cat move quite freely because the rib cage is small in front and there is no collar-bone to cramp the action.

Study this characteristic pose of a sitting cat. Note carefully where the shoulder blades are, and the large curve of the flexible spine.

This crouching gesture is typical. Note the action of the shoulder blades and upper front legs. The extended paw is turned sideways as the cat slaps at some small object.

The kitten is similar to the cat in construction, but the body is shorter and the head larger in proportion.

Head of kitten is round, snout small, eyes large.

This view clearly shows how ears fit on head.

Ears can fold back.

Ear is notched - here.

Construct head, then add hair.

Use center line to relate head and neck.

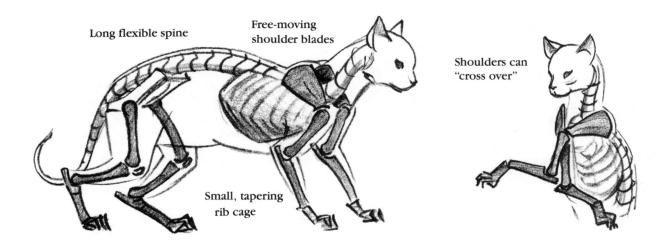

Long flexible spine

Free-moving
shoulder blades

Shoulders can
"cross over"

Small, tapering
rib cage

## *Why the cat is so flexible*

*In these diagrams you can see the characteristics* of the cat's skeleton which allow it such free movement—its small, tapering rib cage, long flexible spine and free-moving shoulder blades and forelegs.

Notice how small the rib cage is at the front. This allows the cat to move its forelegs and shoulder blades almost without restriction—not only forward and backward, but from side to side as well. Because of this feature, the cat can climb with great agility, claw at its prey, and creep along in a crouched position.

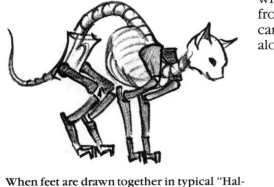

When feet are drawn together in typical "Halloween cat" pose, long spine arches upward.

Note flow of action through entire length of cat.

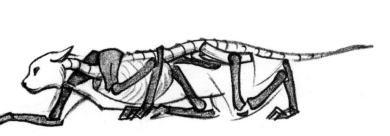

Crouched, creeping action is typical of cat stalking its prey.

# Gaits of the cat

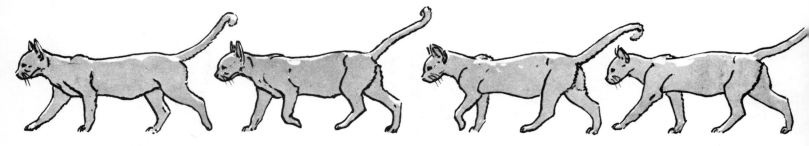

*Walk:* Just as with the dog and horse, the cat's front paw touches the ground a moment after the corresponding rear paw.

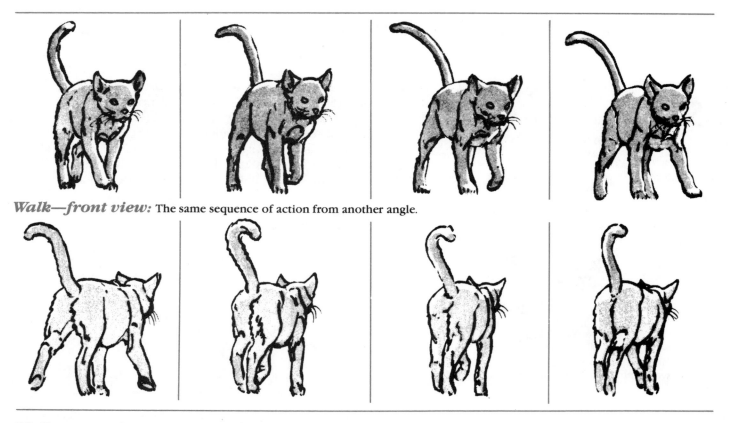

*Walk—front view:* The same sequence of action from another angle.

*Walk—rear view:* Observe how the tail is carried as an aid in balancing.

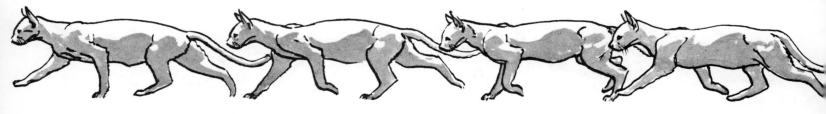

*Trot:* As with other animals, the left front and right hind foot are on the ground at the same time, and the right front foot and left hind foot move together.

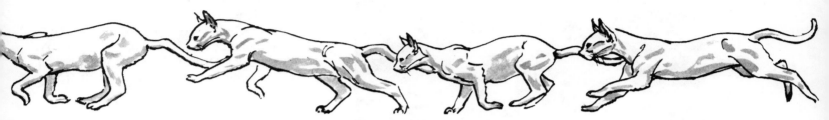

*Gallop:* Here you can see the fluid movement of the cat. Note the prominent action of the shoulder blades as alternate feet are lifted.

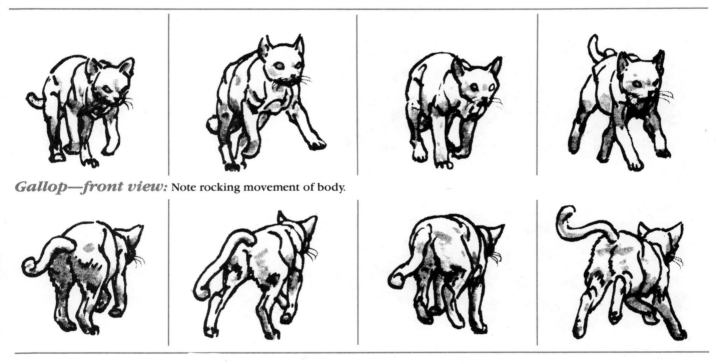

*Gallop—front view:* Note rocking movement of body.

*Gallop—rear view:* See twisting action of tail.

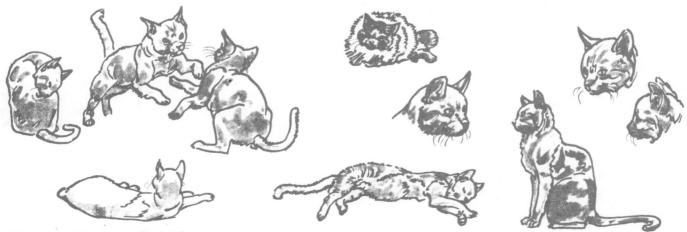

**Cats—asleep and at play.** Draw them whenever you can.

# Practice Project

*There is mystery* and amazing flexibility about a cat, but there's also solid and remarkable structure beneath the fur! Before starting these drawings review pages 54 through 61. Then study each picture carefully, before you put your pencil to paper. Don't just copy, tone for tone. Use your pencil strokes to emphasize the forms beneath the surface.

Refer to the overlay, page 104, for helpful suggestions by a Famous Artists School Instructor.

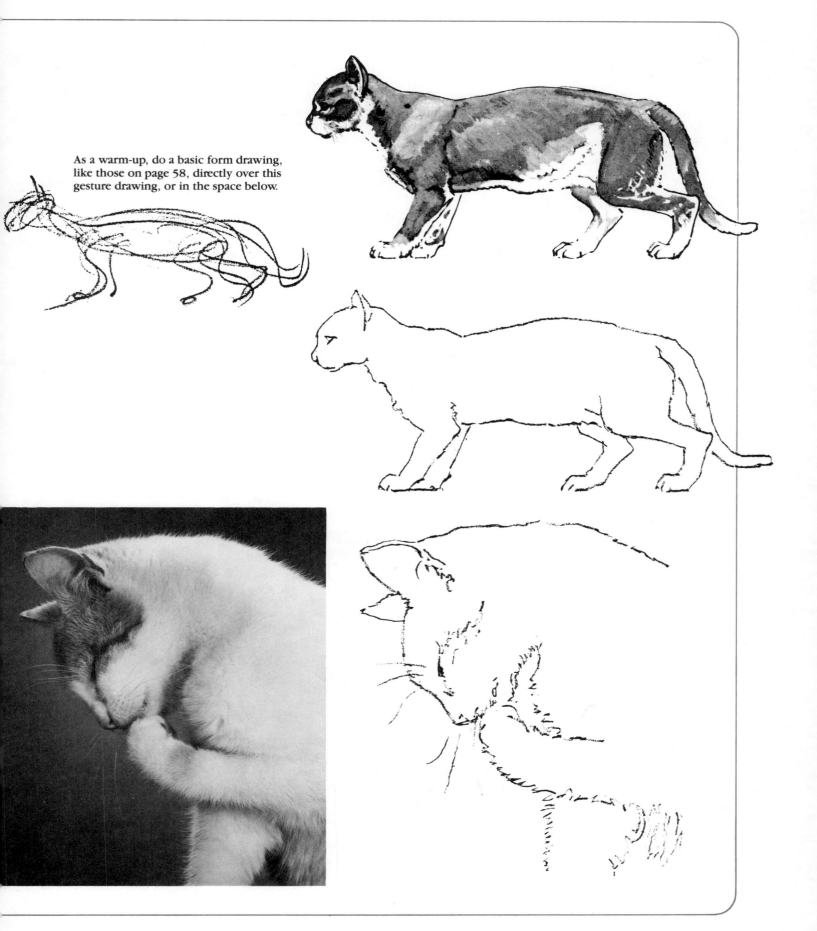

As a warm-up, do a basic form drawing, like those on page 58, directly over this gesture drawing, or in the space below.

# The Cow... *basic forms*

***Whether you want to do a landscape or an illustration*** for a western story or an advertisement for milk, the cow is a valuable animal to know how to draw. It is certainly not a hard one. Both the head and body can be blocked in very much like those of the horse. The chief differences involve proportions: the cow is longer than the horse in relation to its height, and has shorter legs and a wider, shorter head.

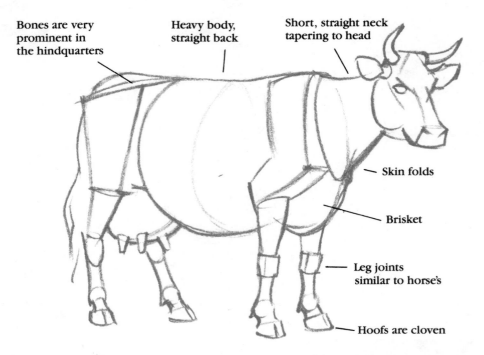

Bones are very prominent in the hindquarters

Heavy body, straight back

Short, straight neck tapering to head

Skin folds

Brisket

Leg joints similar to horse's

Hoofs are cloven

***To block in the cow:*** Use the same procedure you did with the horse, changing the proportions as described in the accompanying text.

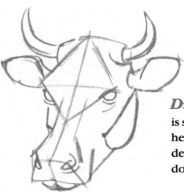

***Drawing the head:*** The method here is similar to the one used in drawing the horse's head. However, the muzzle is much larger and definitely squarish, and the upper lips hang down at the sides.

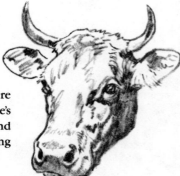

## ...the muscles beneath the skin

**The cow has a short neck**, so normally it does not carry its head high. Except when the animal lifts it to express surprise, the head is usually held slightly below the line of the back. The horns grow out of a bony ridge at the top of the skull. Like other members of the ox family, the cow has noticeable skin folds beneath the neck and a brisket.

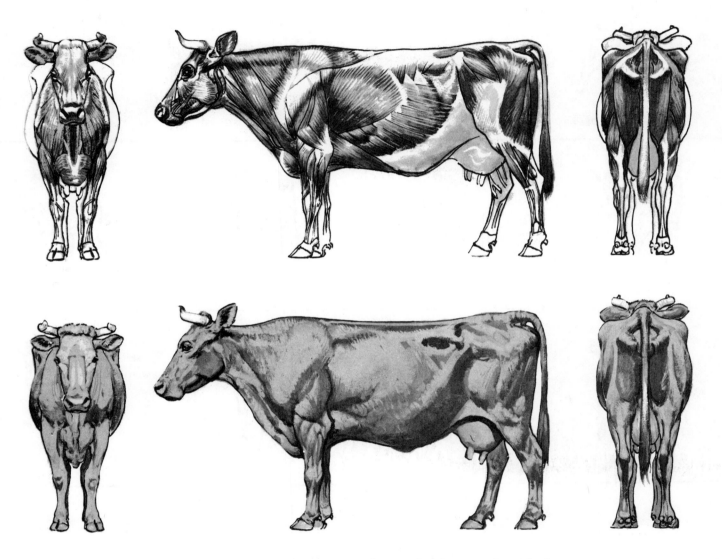

The bony structure is more prominent in the cow than in most other animals.

# Gaits of the cow

**A study of these charts will show you that the cow does not raise** its feet as high as the horse does when walking or running. This is a characteristic to keep in mind when drawing the cow in motion. Sometimes you may wish to exaggerate this action slightly. If you draw a cow with its feet as high as a trotter's, you will have a gay, perky-looking animal.

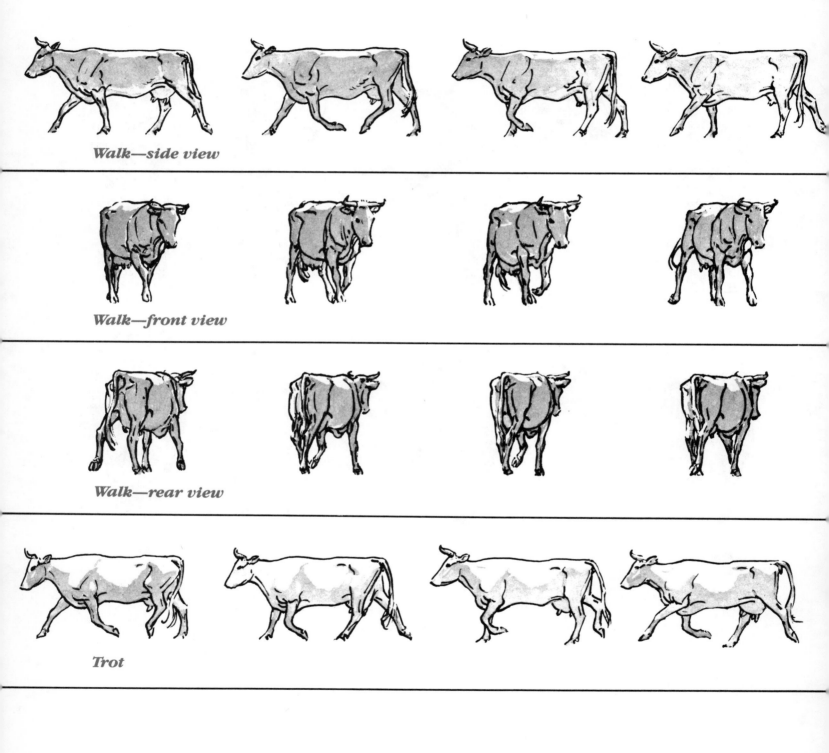

*Walk—side view*

*Walk—front view*

*Walk—rear view*

*Trot*

# You learn to draw by drawing

*Sketch from life whenever you can.* Cattle are ideal subjects, as they move around less than most other animals. If live cattle are not available, draw those you see in photographs in magazines and books and on television. Note the differences in various types of cattle. The calf has a small body and long legs—the bull is sturdy and compact. Draw the animals in all positions—grazing, lying down, getting up. Make studies of details like heads and hoofs. *See—observe—remember.*

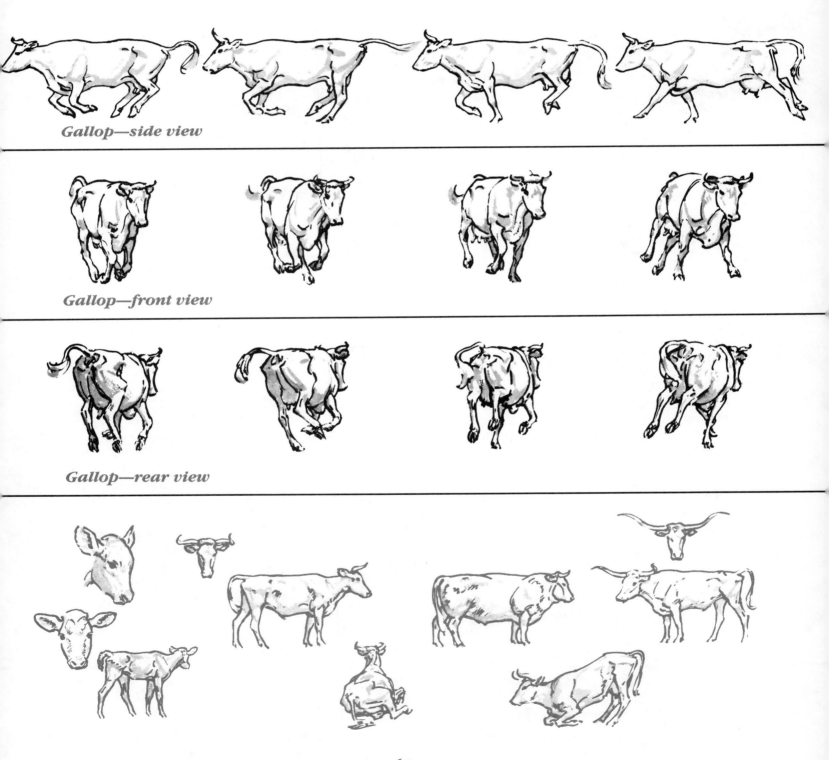

*Gallop—side view*

*Gallop—front view*

*Gallop—rear view*

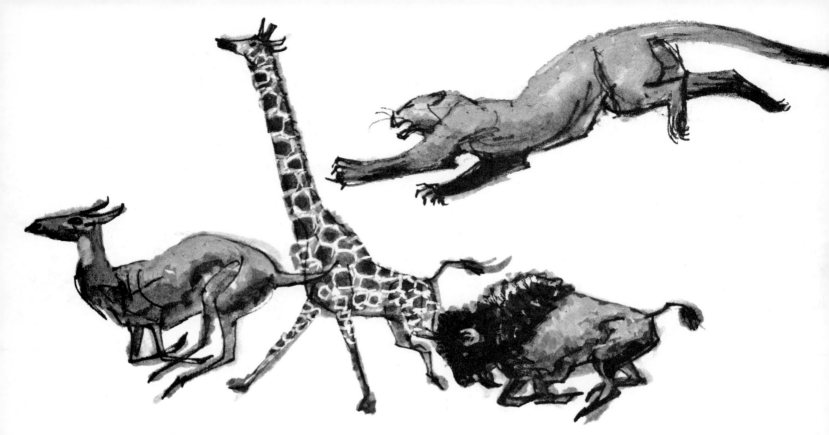

# What Describes an Animal Best?

*Each of the drawings on these pages* emphasizes the special characteristics that give the animal its identity, that describe and express it best. In some animals, hoofed feet and long legs for running are the most distinctive features. Others have claws and short limbs on which to crouch and stalk their prey. Some are climbers, others are gallopers or leapers or jumpers or pouncers. There are those who stick together; others who go it alone.

Think about these things whenever you draw an animal; ask yourself how you can describe it best. Visualize how and where it lives and what it eats. Remember who its enemies are and be particularly aware of the ingenious ways nature has equipped it to fend for itself. If you know and understand the animal first, you communicate something about its essential self in what you draw. That can make the difference between just a competent rendering of an animal and a drawing that looks exciting and alive.

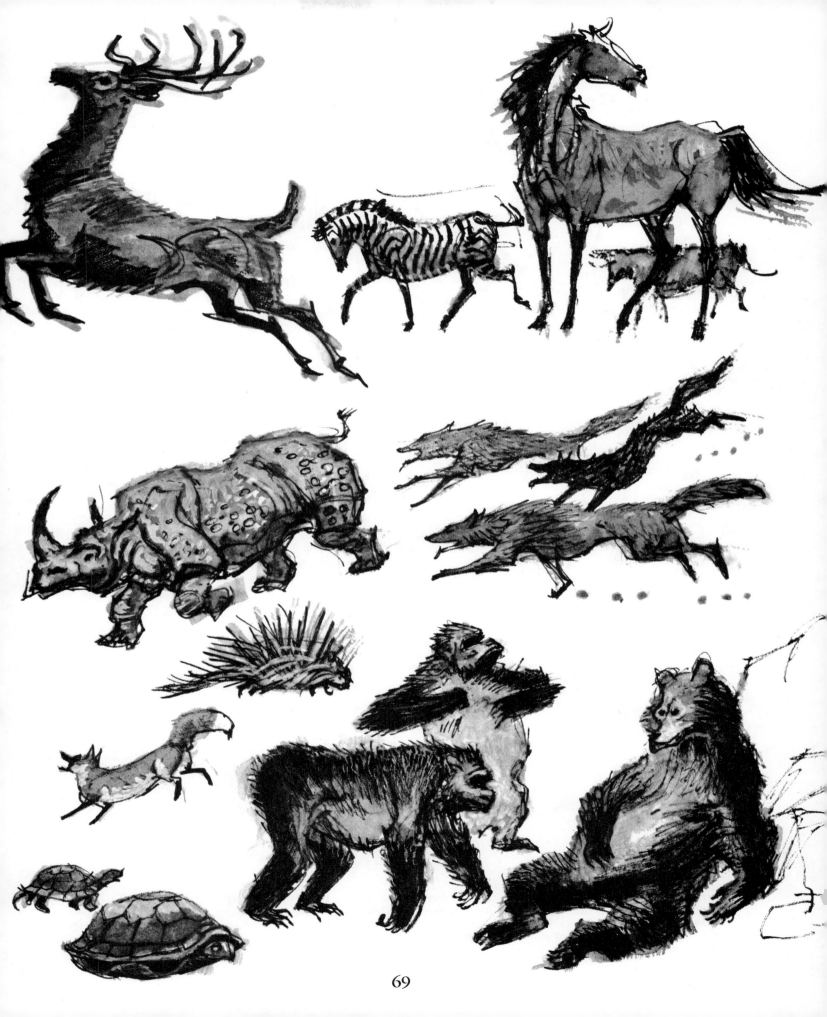

# Animal Profiles

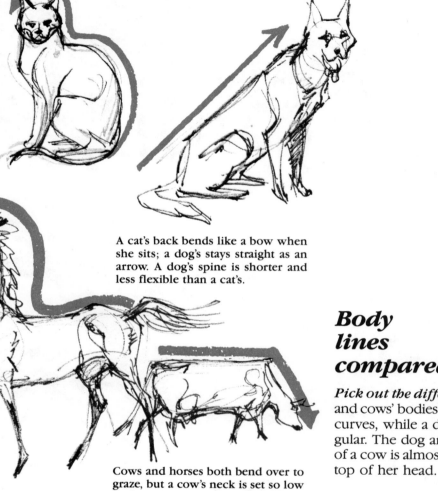

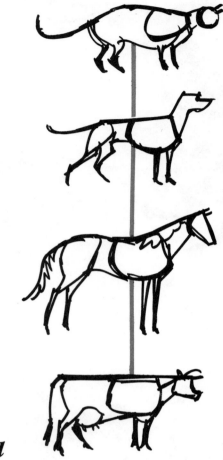

A cat's back bends like a bow when she sits; a dog's stays straight as an arrow. A dog's spine is shorter and less flexible than a cat's.

Cows and horses both bend over to graze, but a cow's neck is set so low on her chest she can't lift her head high, the way a horse can.

## Body lines compared

*Pick out the differences in the way* cats', dogs', horses' and cows' bodies are made. The cat is long, all grace and curves, while a dog's lines are straighter and more angular. The dog and horse have deep chests. The back of a cow is almost perfectly straight from her tail to the top of her head.

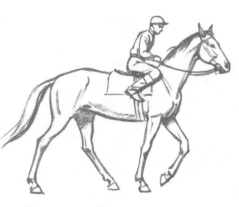

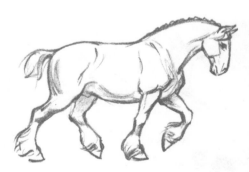

**Show horse:** It is bred and trained to hold its head high and lift its feet in a "prancing" manner. Its rump does not slant downward as much as other horses'.

**Race horse:** Notice the long, thin legs and body. The rider perches well forward so that his weight is supported on the front legs.

**Draft horse:** Descended from the strong, bulky mounts of the heavily armored knights of old, its wide back is ideal for circus performers.

# Head shapes compared

*By learning these basic shapes* you can train your eye to see subtle differences between species of animals—and even the very slight differences that exist among animals of the same species. Some horses, for instance, have very straight faces, others slightly "dished" faces, while still others have a "Roman nose" that curves downward slightly. In general, however, their faces are straight compared to those of the cow, dog, cat, etc.

Within the dog and cat families there is also great variety, but the general shape of the face differs still more strongly from that of other animals. Being aware of the similarities—and the differences—is one of the keys to making a convincing drawing.

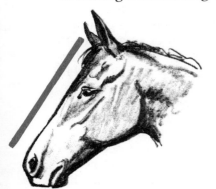 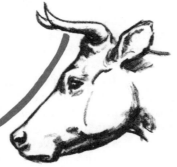 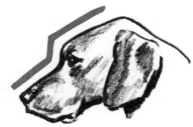 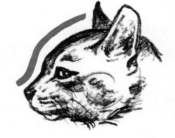

The horse's face is generally straight.

Cows tend to have a "dished" face.

Most dogs have a decided break in the line of the face.

The "step-down" in a cat's face is more gradual.

*Despite the great number of variations* within each of the animal groups, members of the same family (dogs, for instance) resemble each other more than any members of a different family (such as cats).

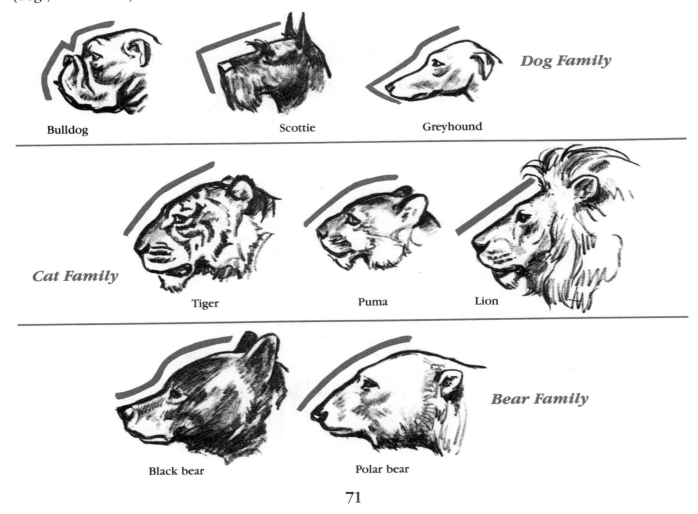

Bulldog

Scottie

Greyhound

*Dog Family*

*Cat Family*

Tiger

Puma

Lion

*Bear Family*

Black bear

Polar bear

# Four Basic Animal Groups

***So far we have concentrated on learning how to draw four basic animals***—the horse, dog, cat and cow. Now you will see how to use your knowledge of these four animals to draw a wide range of other animals—the deer, fox, giraffe, lion, or even such creatures as alligators and seals.

Most of these other animals resemble one of our basic four. For example, the deer is similar to the horse; the fox is like the dog; the lion is really a big cat. Therefore, to start, we will set up four basic groups, one for each of our four basic animals, and place in each group the animals most like the basic one. This grouping is not scientific, but it will show you how to analyze the physical appearance and action of an animal—to use what you know of the basic animal to draw others that are like it. What we show you here is the key to understanding the animals so you can draw them convincingly, even in positions that are not pictured in your reference photographs.

When you study an animal, take particular note of the profile line of its body and of its head. This will help you to get down the animal's characteristic shape quickly. Here we show these lines in color. The features we point out are the type of detail you must train yourself to look for.

One further point: when you draw an animal, don't concentrate merely on its outward appearance. Try to understand its structure and its personality, too—why it moves and behaves the way it does. This approach will help you not only to draw the animal accurately, but to capture its character and spirit as a unique living thing.

The cat's body profile line is long and flexible.

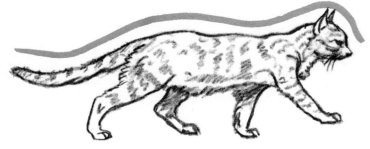

## Cat group

Animals in this group are the real hunters of the animal kingdom. They are equipped with knifelike teeth and powerful front legs, and armed with sharp claws which they can extend or draw in at will. Stealth, surprise attack and, except for the lion, concealment are their native habits. With long, flexible bodies, no wider at any point than the head, they pass through any opening the head can enter. There are many small animals such as the otter, weasel, and skunk that are not really cats but are similar in structure, and your knowledge of cats will help you draw them.

Long, flexible body and tail

Typical cat shoulder action

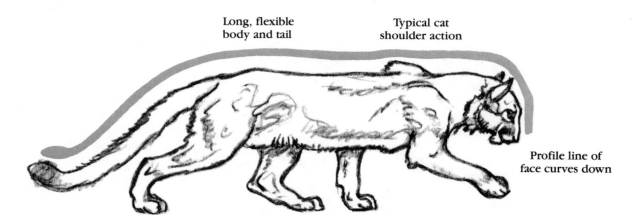

Profile line of face curves down

***Puma:*** The puma or mountain lion is a big, agile cat. A typical hunter, it stalks its prey, then springs into action, attacking with its powerful forelegs and teeth.

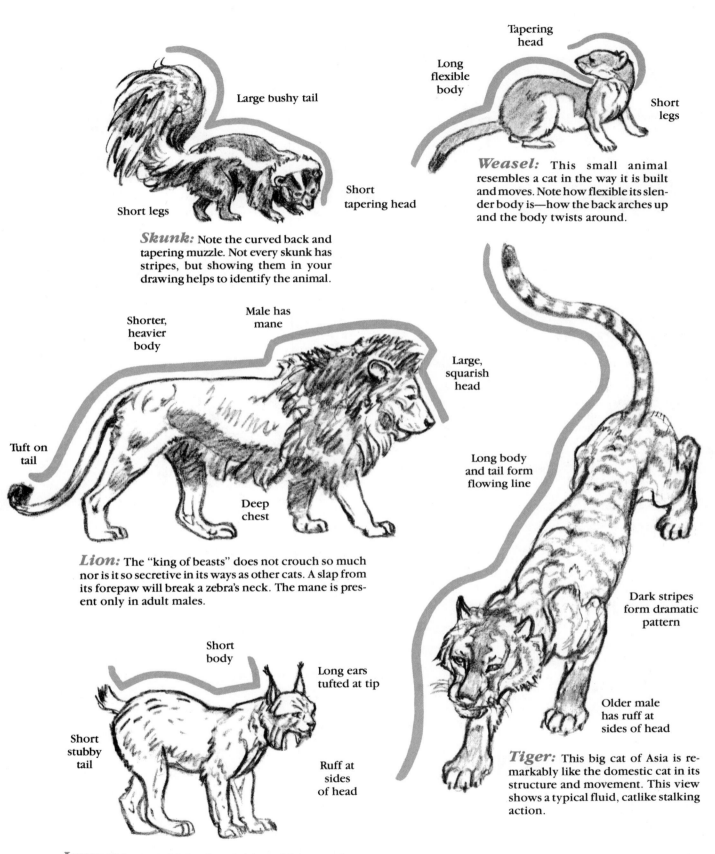

Large bushy tail

Short legs

Short tapering head

Tapering head

Long flexible body

Short legs

**Weasel:** This small animal resembles a cat in the way it is built and moves. Note how flexible its slender body is—how the back arches up and the body twists around.

**Skunk:** Note the curved back and tapering muzzle. Not every skunk has stripes, but showing them in your drawing helps to identify the animal.

Shorter, heavier body

Male has mane

Large, squarish head

Tuft on tail

Deep chest

Long body and tail form flowing line

**Lion:** The "king of beasts" does not crouch so much nor is it so secretive in its ways as other cats. A slap from its forepaw will break a zebra's neck. The mane is present only in adult males.

Dark stripes form dramatic pattern

Short body

Long ears tufted at tip

Short stubby tail

Ruff at sides of head

Older male has ruff at sides of head

**Tiger:** This big cat of Asia is remarkably like the domestic cat in its structure and movement. This view shows a typical fluid, catlike stalking action.

**Lynx:** This cat, with its short body and long rear legs, is less graceful than most others. Its large feet are useful on snow.

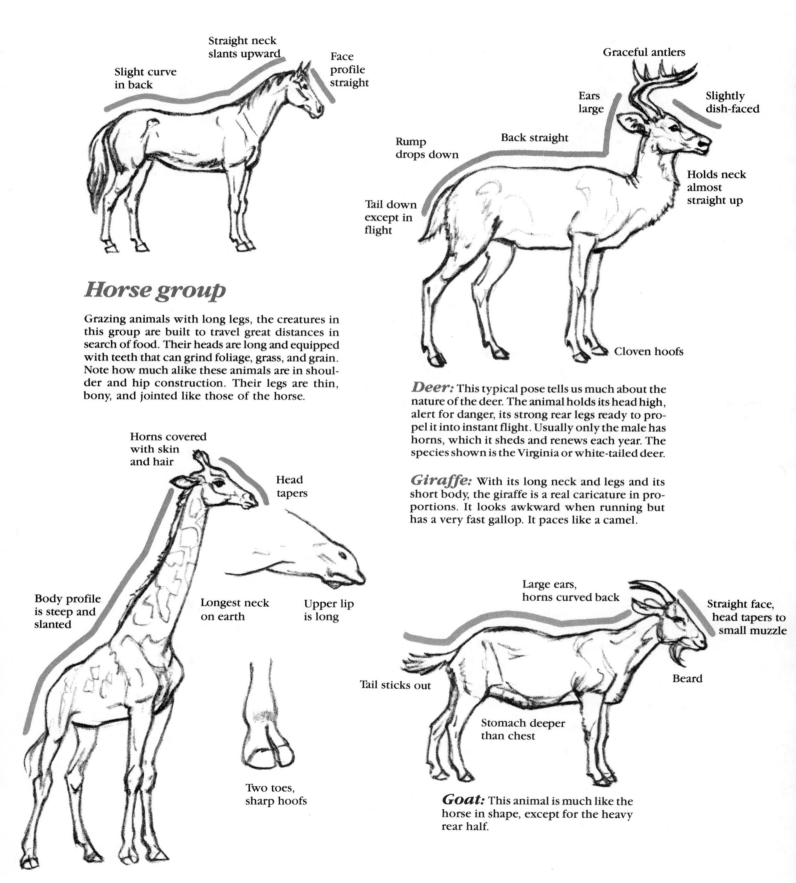

Straight neck
slants upward

Slight curve
in back

Face
profile
straight

## Horse group

Grazing animals with long legs, the creatures in this group are built to travel great distances in search of food. Their heads are long and equipped with teeth that can grind foliage, grass, and grain. Note how much alike these animals are in shoulder and hip construction. Their legs are thin, bony, and jointed like those of the horse.

Graceful antlers

Ears
large

Slightly
dish-faced

Rump
drops down

Back straight

Holds neck
almost
straight up

Tail down
except in
flight

Cloven hoofs

**Deer:** This typical pose tells us much about the nature of the deer. The animal holds its head high, alert for danger, its strong rear legs ready to propel it into instant flight. Usually only the male has horns, which it sheds and renews each year. The species shown is the Virginia or white-tailed deer.

**Giraffe:** With its long neck and legs and its short body, the giraffe is a real caricature in proportions. It looks awkward when running but has a very fast gallop. It paces like a camel.

Horns covered
with skin
and hair

Head
tapers

Body profile
is steep and
slanted

Longest neck
on earth

Upper lip
is long

Two toes,
sharp hoofs

Large ears,
horns curved back

Straight face,
head tapers to
small muzzle

Tail sticks out

Beard

Stomach deeper
than chest

**Goat:** This animal is much like the horse in shape, except for the heavy rear half.

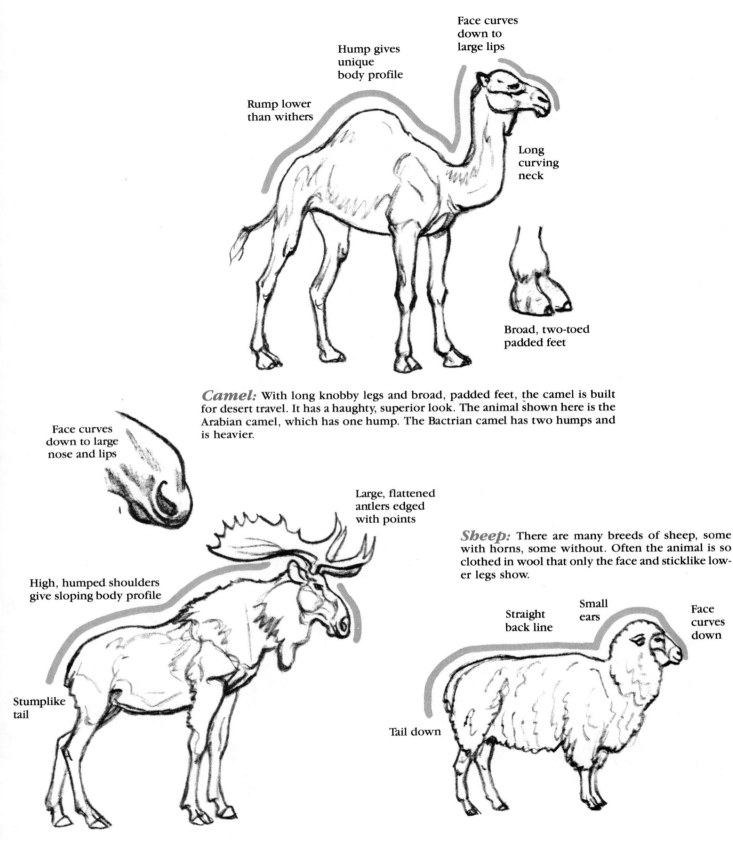

Face curves
down to
large lips

Hump gives
unique
body profile

Rump lower
than withers

Long
curving
neck

Broad, two-toed
padded feet

**Camel:** With long knobby legs and broad, padded feet, the camel is built for desert travel. It has a haughty, superior look. The animal shown here is the Arabian camel, which has one hump. The Bactrian camel has two humps and is heavier.

Face curves
down to large
nose and lips

Large, flattened
antlers edged
with points

High, humped shoulders
give sloping body profile

Stumplike
tail

**Sheep:** There are many breeds of sheep, some with horns, some without. Often the animal is so clothed in wool that only the face and sticklike lower legs show.

Small
ears

Straight
back line

Face
curves
down

Tail down

**Moose:** Largest of the deer family, the moose has clumsy-looking proportions. Notice its short body and large head. Its neck is so short, the animal must kneel to eat grass.

# Dog group

Animals like the wolf, fox, hyena, and coyote show a marked resemblance to the dog. All are meat eaters and follow their prey through their keen sense of smell. Their long legs and good lung capacity meet the two prime demands of the chase—speed and endurance. They strike with teeth and strong jaws, their forepaws having almost no part in making the kill.

As we have mentioned before, different types of dogs vary considerably. We are again using the "average" dog here as a standard for comparison.

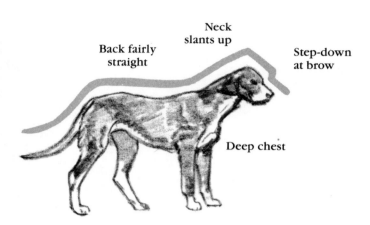

Back fairly straight

Neck slants up

Step-down at brow

Deep chest

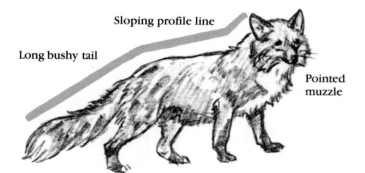

Head and neck, carried low, give flatter body profile line

Long face, sharp muzzle

Tail down

**Wolf:** A large, wild, doglike animal, the wolf has coarse fur, a bushy tail, and erect, pointed ears. It carries its head and neck lower than the dog does.

Sloping profile line

Long bushy tail

Pointed muzzle

**Fox:** This sly, clever fellow looks much like a long-haired dog. The fox is smaller than the wolf and has triangular ears that remind us of the cat's.

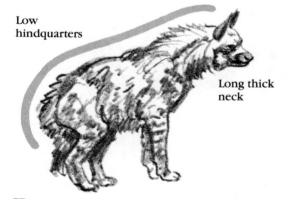

Low hindquarters

Long thick neck

**Hyena:** This repulsive creature is not actually kin to a dog but resembles it in basic structure. A notable difference is in the short rear legs, which give the animal its unusual body profile. Its coat is rough.

76

# Cow group

Like the horse group, these animals are grazers. Physically, there is much resemblance, too. The main difference is in the shorter legs and heavier bodies, which give the animals less mobility.

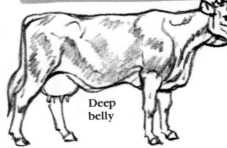

Body and neck form fairly straight line

Slightly dish-faced

Deep belly

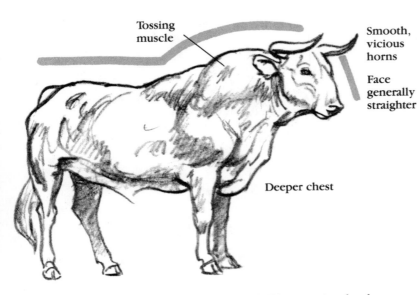

Tossing muscle

Smooth, vicious horns

Face generally straighter

Deeper chest

**Bull:** Seemingly built for attack, the bull has massive shoulder and neck muscles. Notice how bulky the bull is toward the front—while the cow, with its deep belly, is bulky toward the rear.

**Zebu:** The Brahma bull has a large hump above the shoulders.

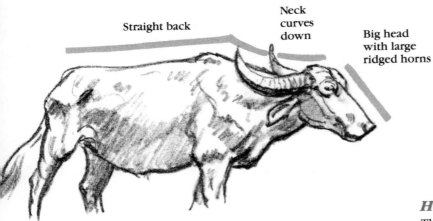

Straight back

Neck curves down

Big head with large ridged horns

**Water buffalo:** This powerfully built ox, used as a draft animal in Asia, is quite similar in structure to the cow and bull but is bigger. Its large head seems weighed down by its big horns.

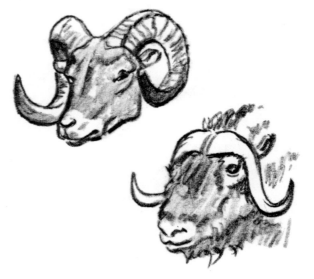

## Horns

The variety of horns in this group and the sheep and goats is almost limitless. Some horns are curving, others are twisted, spiral, or straight. Here we see the magnificent spiral horns of the Rocky Mountain bighorn sheep contrasted with the musk ox's broad-based horns which curve down along its jaws.

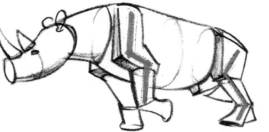

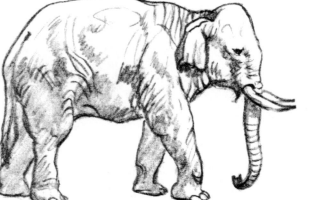

**Rhinoceros:** Although different in proportions, the rhino is similar to the elephant in most of its basic forms. Its legs seem quite stubby, but the animal trots and gallops much like a horse.

**Elephant:** To block in the elephant, use the basic animal forms for the body, hips, and shoulders —add the "stove pipe" legs and egg-shaped head with trunk and tusks. You will need photos for the details and texture of the loose hide.

# Don't Let Hide nor Hair Fool You!

*Although many of these animals would be difficult to fit into our four groups,* all are basically similar to them in their bone and muscle framework. Your knowledge of the four basic animal groups will help you draw the animals, even though some are covered with heavy hide, like the hippo and rhino, or with quills, like the porcupine, or with long hair, like the llama.

Whenever you draw an animal, besides considering its outside appearance, pay attention to the way the shoulder blades and leg bones work. (We have indicated these with colored lines on the diagrams.) This action, which is much the same for all animals, controls their movement and must be understood if your drawing is to have a sense of life and carry real conviction. See how basic forms similar to those used for the horse, cow, dog, and cat are used here to block in even the alligator and sea lion!

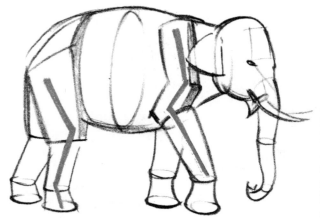

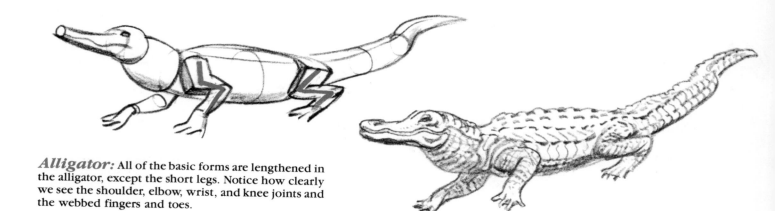

**Alligator:** All of the basic forms are lengthened in the alligator, except the short legs. Notice how clearly we see the shoulder, elbow, wrist, and knee joints and the webbed fingers and toes.

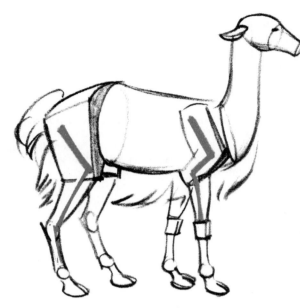

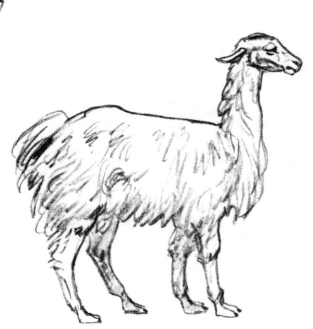

***Llama:*** Under its long hair, the llama is much like the horse and camel in basic structure. It has padded, two-toed feet like the camel.

*You will be most likely to encounter* these more exotic or unusual animals through photographs. In cases where photography is your only reference, study the structure and action of the animal by means of an analytical basic form figure. An easy way to do this is through the use of tracing paper laid over the photograph.

For a description of this tracing paper method, see page 96.

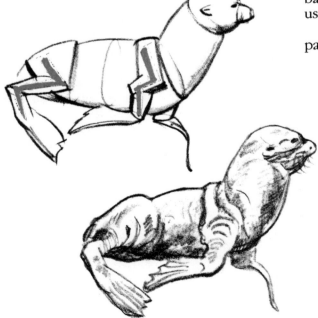

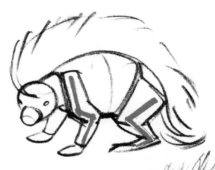

***Porcupine:*** The basic forms will help you draw even the strange-looking porcupine. Use them to establish the correct leg action under the mass of quills.

***Sea lion:*** A close look shows that the sea lion, like other seals and walruses, has much the same basic structure as the land animals, although its "hands" and "feet" are webbed.

# Things to Remember

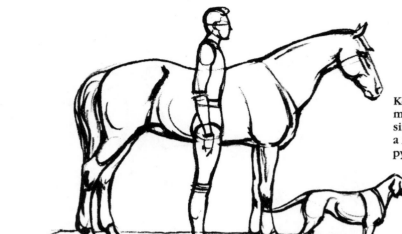

Keep your drawings of animals in scale. Although animals of the same species do vary in size, the comparative size of each species remains constant. When drawing a man alongside a horse, don't make him a giant or a pygmy—unless he is one.

Draw the rider so that he rests *on* the saddle, not *in* the horse. "Draw through" the horse's back and saddle to get the placement right.

Wrong

Right

*Wrong:* The tail is not just a clump of hairs merely "tacked on."

*Right:* The tail is actually a continuation of the spine and flows smoothly from it.

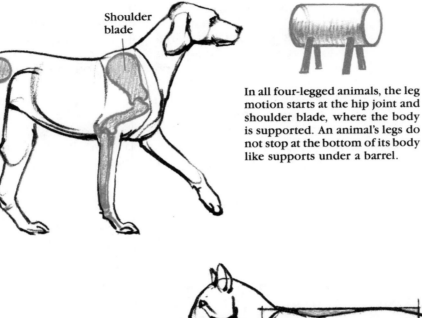

Hip
joint

Shoulder
blade

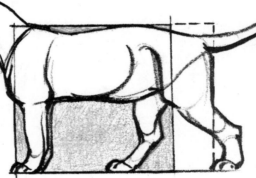

In all four-legged animals, the leg motion starts at the hip joint and shoulder blade, where the body is supported. An animal's legs do not stop at the bottom of its body like supports under a barrel.

The cat's body is quite long in comparison to its height. Unlike the body of the average horse and dog, it does not fit into a square.

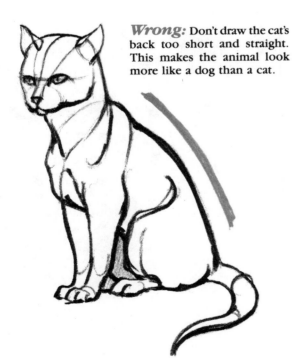

*Wrong:* Don't draw the cat's back too short and straight. This makes the animal look more like a dog than a cat.

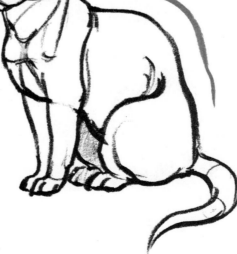

*Right:* The cat's body is *long* (see diagram above) and its back arches decidedly in a seated position such as this one.

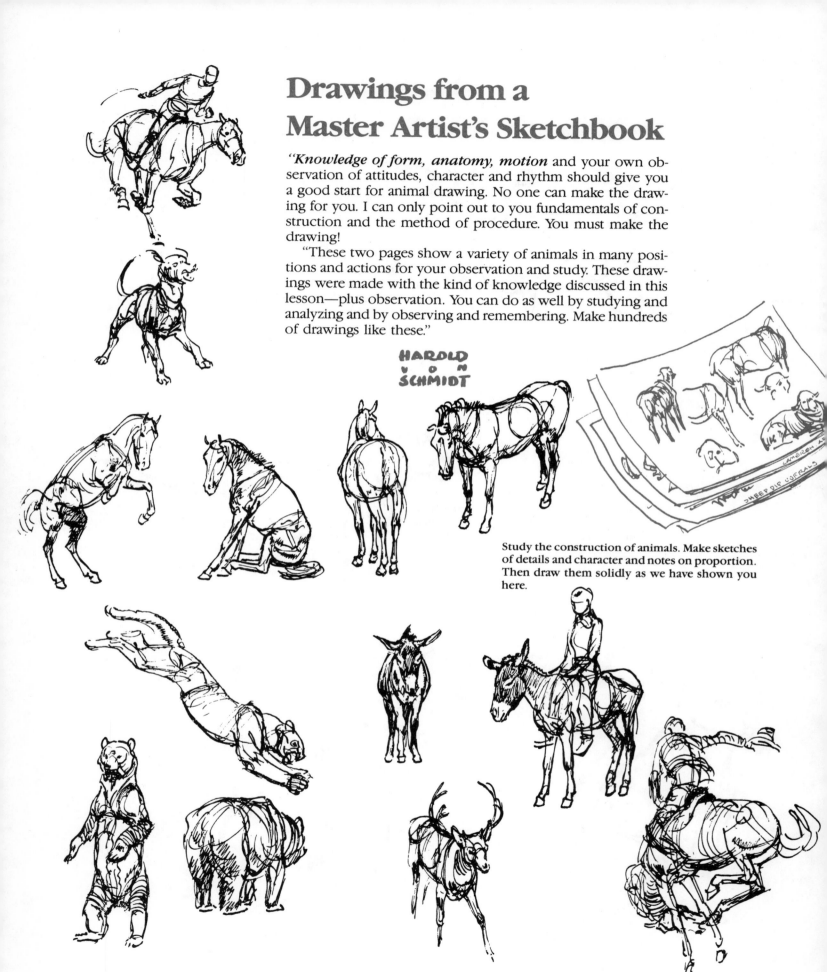

# Drawings from a Master Artist's Sketchbook

*"Knowledge of form, anatomy, motion* and your own observation of attitudes, character and rhythm should give you a good start for animal drawing. No one can make the drawing for you. I can only point out to you fundamentals of construction and the method of procedure. You must make the drawing!

"These two pages show a variety of animals in many positions and actions for your observation and study. These drawings were made with the kind of knowledge discussed in this lesson—plus observation. You can do as well by studying and analyzing and by observing and remembering. Make hundreds of drawings like these."

HAROLD SCHMIDT

Study the construction of animals. Make sketches of details and character and notes on proportion. Then draw them solidly as we have shown you here.

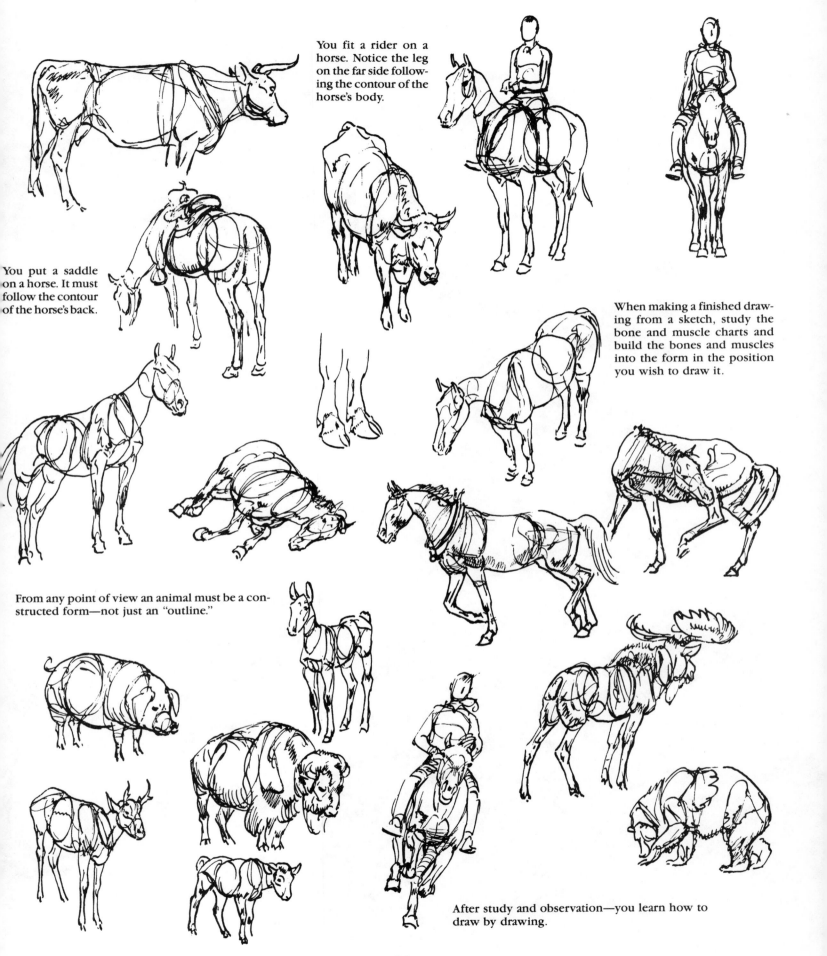

You fit a rider on a horse. Notice the leg on the far side following the contour of the horse's body.

You put a saddle on a horse. It must follow the contour of the horse's back.

When making a finished drawing from a sketch, study the bone and muscle charts and build the bones and muscles into the form in the position you wish to draw it.

From any point of view an animal must be a constructed form—not just an "outline."

After study and observation—you learn how to draw by drawing.

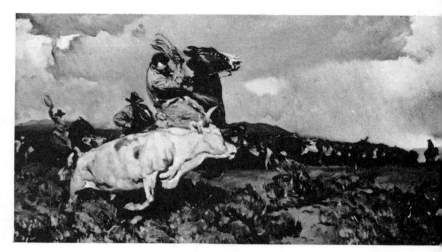

Harold Von Schmidt communicates dramatic tensions in this painting of cowboys rounding up cattle before an approaching storm.

A dark, looming mass of awesome strength —that is how this Alaskan brown bear is pictured by the artist, Fred Ludekens.

# Animal pictures...

*Pictures of animals* can stir many of the same emotions in us that pictures of people do. Often the impact of the animal is even stronger. From the childhood moment when we are first amused by a kitten's high spirited attack on a ball of yarn, or awed by the towering gray bulk of an elephant at the zoo, animals take on a deep, inner meaning for us. They become almost like symbols, strongly charged with the electricity of the emotions.

As this splendid bull elk bugles his ringing challenge, we sense his readiness to meet all comers.

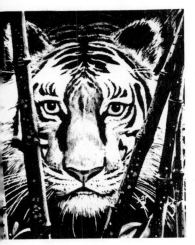

The mysterious, almost hypnotic stare of the tiger is forcefully expressed here.

## with real meaning

Study the illustrations here and see how the artists use animals as emotional symbols to create a response in the viewer. Notice, too, how clearly these artists express the personality or feelings of the animal itself. Don't merely catalog factual details when you draw and paint animals—you must respond to them emotionally and communicate their emotions to the viewer to bring your animals to life.

When man matches his skill and muscle against a bucking bronco, the action is swift and dramatic.

# Practice Project

*Pumas, bears, bulls, lions*—they are all members of the amazing family of animals. But in spite of their differences, they all have basic similarities of structure that make them easier to draw.

Have fun with this assortment, and then refer to the Instructor Overlay, pages 105 and 106, for helpful suggestions and interpretations.

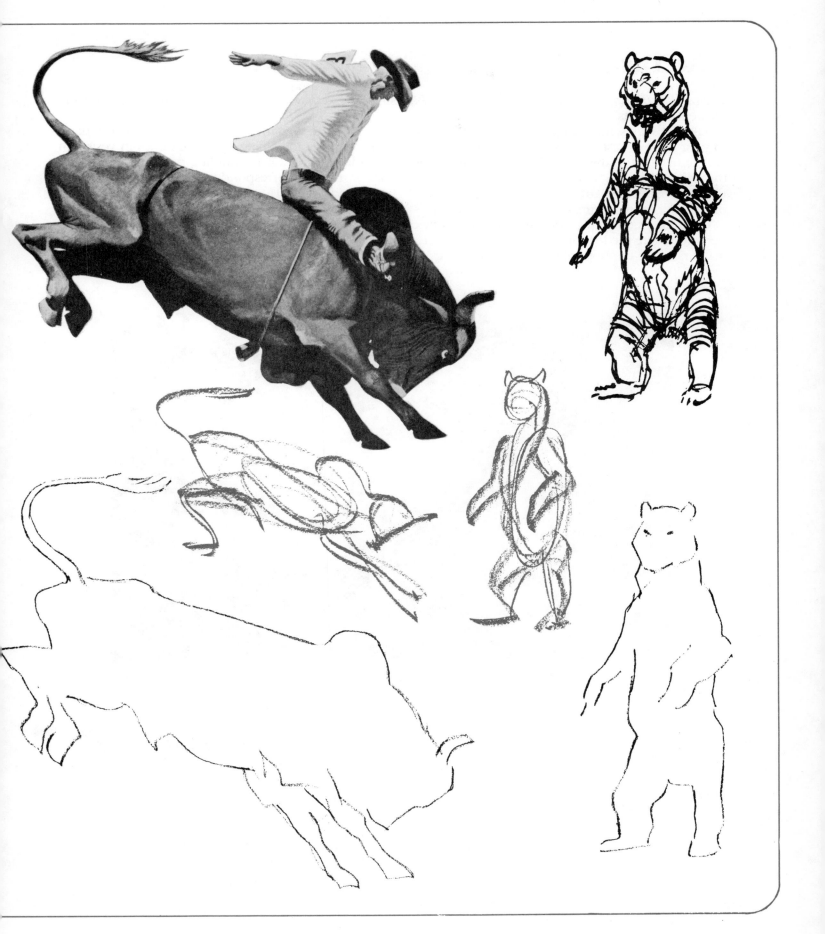

**Section 8**

# The Bird

*The bird, with its feathery coat and gift of flight*, seems a far different creature from man. Yet it has many of the same parts that he does.

Take the wings, for example. In their bony structure they are quite similar to our arms. If you put your hand to your upper chest and bend your wrist down, as in the figure on the facing page, the bones in your arm will actually be in the same position as the bones in the folded wing. Or try holding your arms out, as in the winged figure at the left. You can easily see how your arm bones correspond to the bones of the wing.

Like a man's legs, the legs of a bird have a "hip," "knee," and "heel." However, the bird is closer to most of the four-footed animals in its posture: it stands on its toes with its heel up from the ground.

Carefully examine the bird's skeleton on the next page and you will see where the wing joins at the shoulder and where the leg joins at the hip. This latter point is difficult to observe on the living bird because the feathers cover the upper leg from hip to knee, so that the leg appears to start at the knee.

HAROLD VON SCHMIDT

© The Curtis Publishing Co.

The bones in a wing correspond closely to those in a man's arm

Shoulder
Elbow
Hand

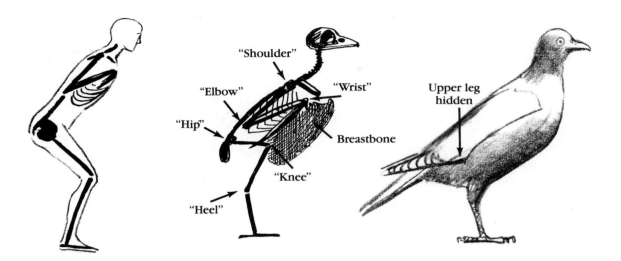

## *Understanding the structure of a bird*

**Man and bird are surprisingly alike** in their skeletal structure.

The bird has a large breastbone, shaped somewhat like the keel of a boat, to which its well-developed flight muscles are attached.

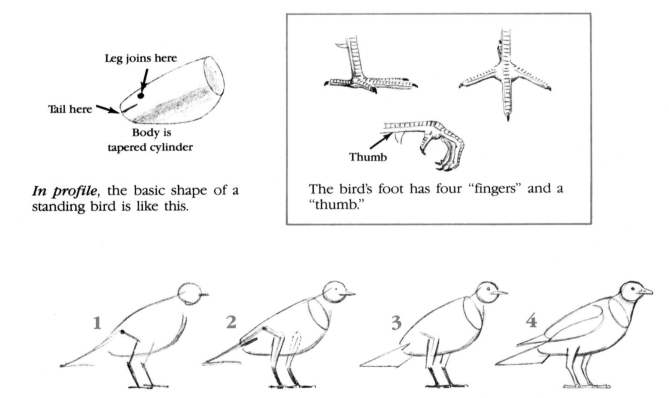

*In profile*, the basic shape of a standing bird is like this.

The bird's foot has four "fingers" and a "thumb."

## *How to draw a bird...step by step*

**Different species vary in their proportions**, but you can still use basic forms to draw birds. These forms can be changed and adapted to fit whatever type of bird you draw. First sketch the general position and shape, then build the simple basic forms.

# The bird in flight

***The basic flying action for all birds is the same.*** The wing moves forward and down, then back and up, the way your arm does when you swim the crawl stroke. With its feathers closed, the wing "bites" into the air just as your hand does in the water when the fingers are closed. At the end of your stroke you turn your hand and raise it through the water to minimize resistance. The bird does a similar thing—at the end of the stroke it lifts the wing and separates and turns the feathers, allowing the air to slip through. The bird gains its lift or flight-sustaining force by creating a vacuum over the top of the wing, causing the air pressure below to thrust it upward.

Although all birds fly in much the same way, there are differences in the details of the movements. The tiny hummingbird, for example, beats its wings as rapidly as two hundred times a second, while the long-winged pelican beats them only one or two times a second.

In fight the legs extend straight back. The tail is in a relaxed, horizontal position except when brought into use to help control the direction of flight.

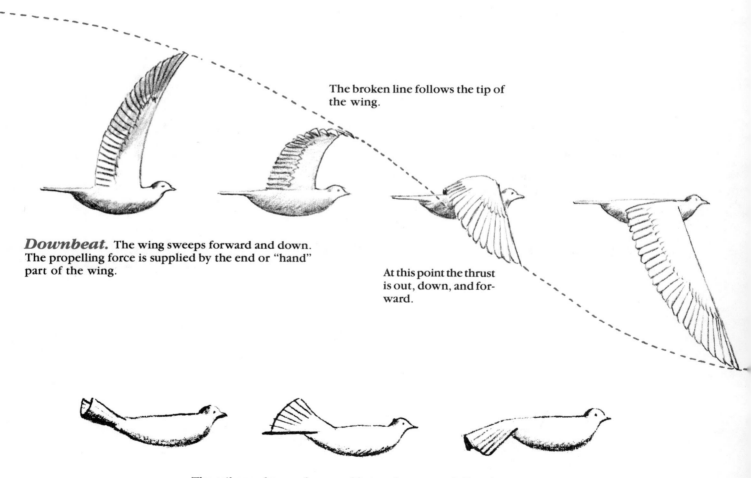

The broken line follows the tip of the wing.

**Downbeat.** The wing sweeps forward and down. The propelling force is supplied by the end or "hand" part of the wing.

At this point the thrust is out, down, and forward.

The tail can change shape and be used to control direction, to slow the bird, or to help it go up or down. The tail can also be twisted for a turn or banking movement.

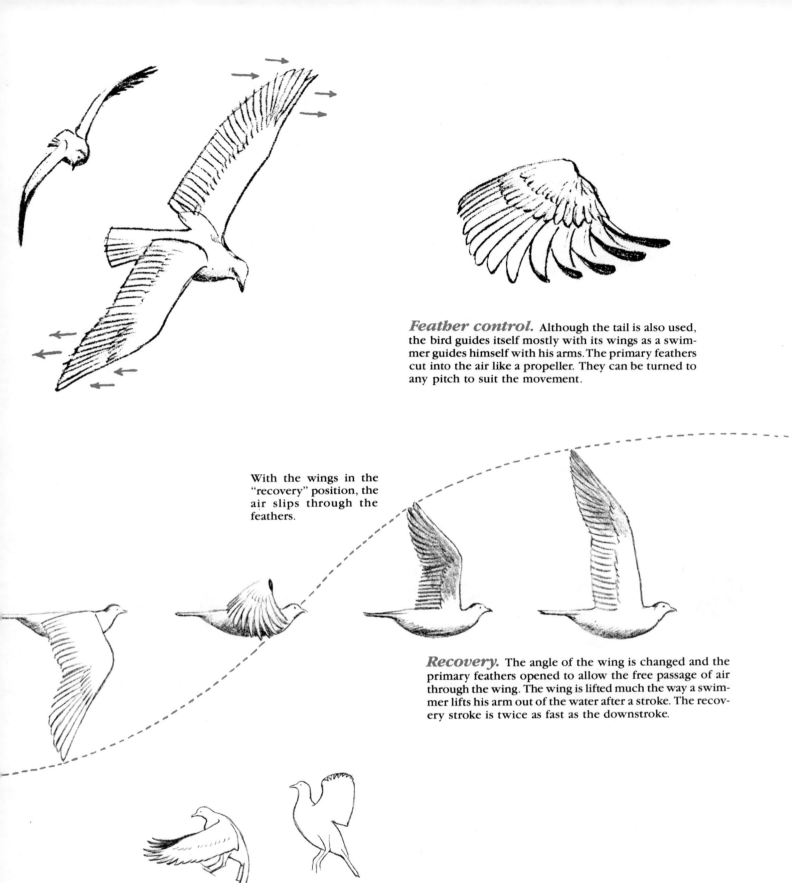

**Feather control.** Although the tail is also used, the bird guides itself mostly with its wings as a swimmer guides himself with his arms. The primary feathers cut into the air like a propeller. They can be turned to any pitch to suit the movement.

With the wings in the "recovery" position, the air slips through the feathers.

**Recovery.** The angle of the wing is changed and the primary feathers opened to allow the free passage of air through the wing. The wing is lifted much the way a swimmer lifts his arm out of the water after a stroke. The recovery stroke is twice as fast as the downstroke.

Landing      Climbing

# Wings...design and action

*The wings of all birds* have the same basic structure but they vary depending upon the needs and habits of different species. Soaring birds have wide wingspans and can glide for miles, taking advantage of air currents. Other birds fly shorter distances and must make sudden changes of direction to catch insects or avoid danger. As mentioned earlier, the hummingbird beats its tiny wings at an incredible speed.

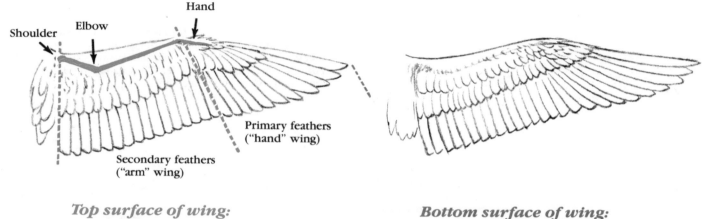

Shoulder
Elbow
Hand

Primary feathers ("hand" wing)

Secondary feathers ("arm" wing)

### Top surface of wing:
Note direction of overlap feathers.

### Bottom surface of wing:
Note reverse overlap of feathers.

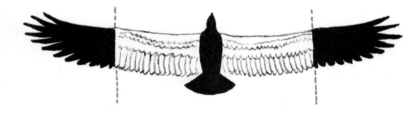

Soaring bird has a long "arm" for lift, and a slow wing-beat—typical of such birds as the eagle, gull, albatross, etc.

Fast, short flyer can make quick getaway with action of "hand" wing and rapid wingbeats. Grouse and pheasant are birds of this kind.

### How a bird folds its wings

The wing is moved back and up at the start of the action. Each outer section fits under the next section going toward the body.

# How to draw birds in flight

*Using the same basic head and body shapes* as for the standing bird, on each side we add a wing composed of a rectangle and a triangle. These basic shapes, changed slightly, can indicate many different positions of flight. The proportions will vary with the type of bird.

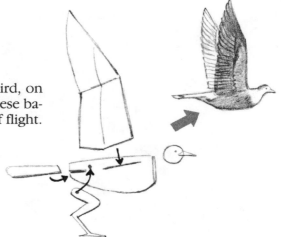

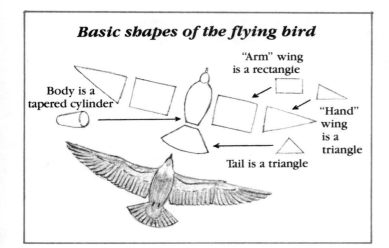

### Basic shapes of the flying bird

Body is a tapered cylinder

"Arm" wing is a rectangle

"Hand" wing is a triangle

Tail is a triangle

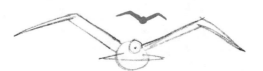

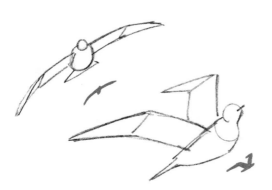

Begin with just the gesture of the wing shapes. Then recreate them by means of the basic shapes as shown.

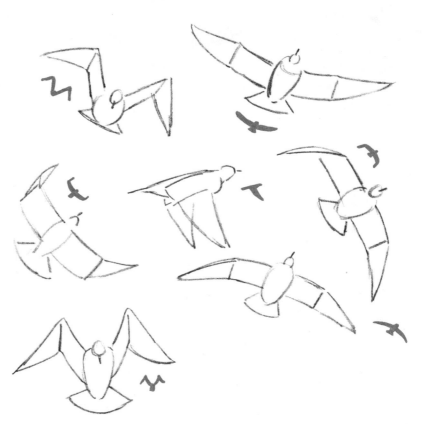

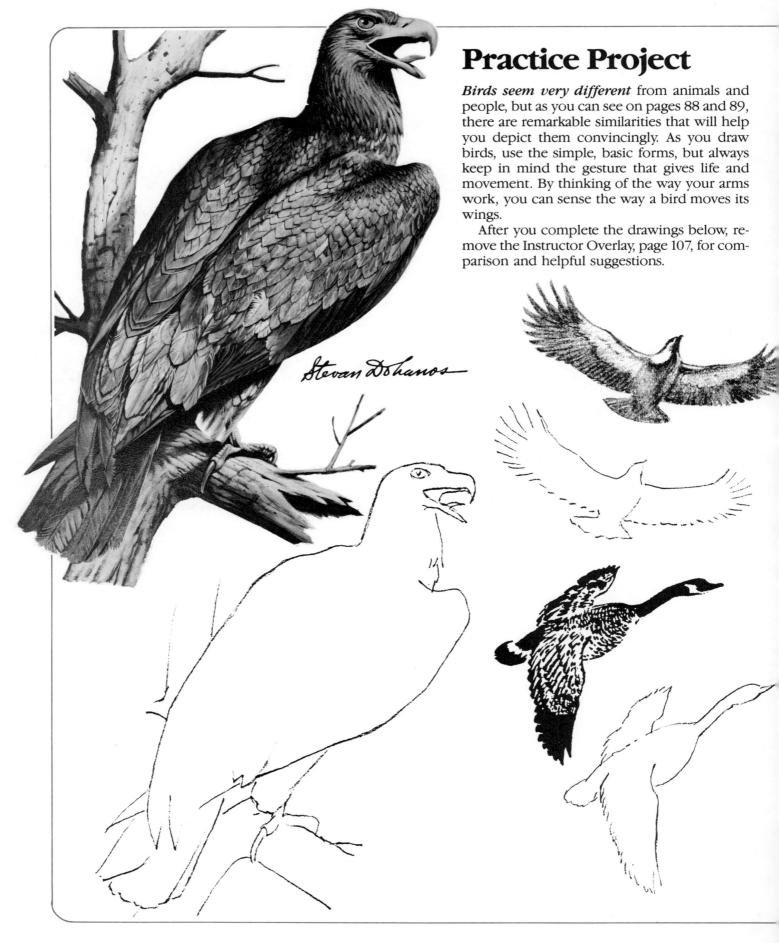

# Practice Project

*Birds seem very different* from animals and people, but as you can see on pages 88 and 89, there are remarkable similarities that will help you depict them convincingly. As you draw birds, use the simple, basic forms, but always keep in mind the gesture that gives life and movement. By thinking of the way your arms work, you can sense the way a bird moves its wings.

After you complete the drawings below, remove the Instructor Overlay, page 107, for comparison and helpful suggestions.

Stevan Dohanos

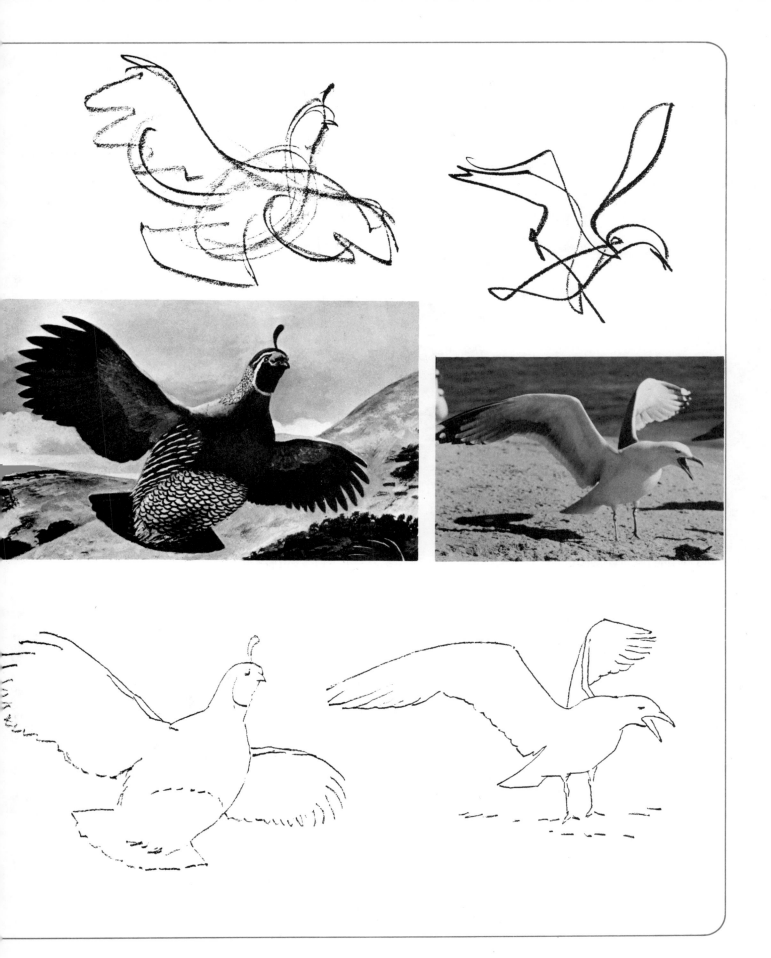

# Think with Tracing Paper

*The beauty of using tracing paper is that* it allows you to first make a preliminary trial drawing; then, because it's transparent, you can slip it under a clean sheet and proceed to correct and adjust as you redo the drawing.

You can repeat this as many times as it takes. Be sure, however, that you *don't just mindlessly trace.* Make each successive drawing an improvement, and strive for spontaneity in every new version.

**1** *New sheet:* Fasten a sheet of tracing paper over your sketch and do a new drawing, using your previous one as a guide and making the necessary improvements.

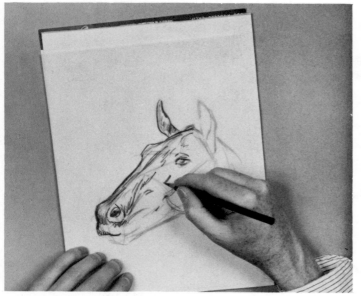

**2** *Refining your drawing:* If your drawing needs further adjustments, place a clean sheet of tracing paper over it and continue developing it to the degree of finish you wish.

# Transfer with Tracing Paper

*It's easy to transfer the outlines of a drawing* onto another surface. First, lay a sheet of tracing paper over the picture you wish to duplicate and, with a medium soft pencil, trace the main outlines. Then follow the steps below. If your original drawing was done on tracing paper, as described to the left, just turn it over, blacken the back of the outlines, and trace it down. This method gives you a clean surface on which to work, free from erasures and smears.

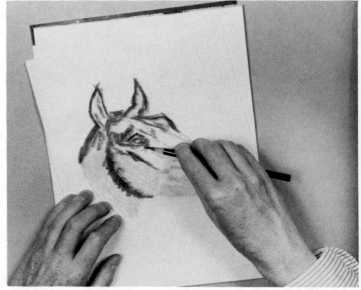

**1** *Preparing the back:* Turn your tracing over and blacken the paper right over the back of your traced lines with a soft pencil.

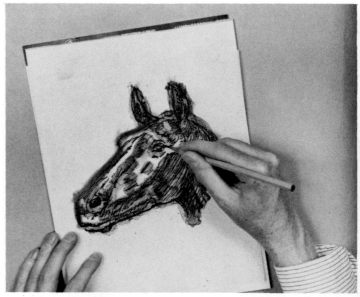

**2** *Transferring:* Tape the top corners of your tracing onto the surface on which you plan to draw or paint. With a sharp pencil trace over the outlines and they will be transferred to your drawing surface.

# Tracing Papers... *the following pages include these items:*

**11 Instructor Overlays.** These demonstrations show how instructors at Famous Artists School completed the Practice Projects. Remove them to compare with your own project drawings.

**5 Blank sheets of tracing paper.** These will give you a chance to try out this useful and popular type of paper. Similar paper is readily available at stores selling art supplies.

**FREE ART LESSON.** This is the most important project of all. You'll find it at the end of the book. Complete it and mail it to get a free evaluation from the instruction staff of Famous Artists School.

**Note:** Slip a sheet of white paper under this page for easy reading.

---

## Instructor Overlay... *gesture drawings.*
For Practice Project on page 24.

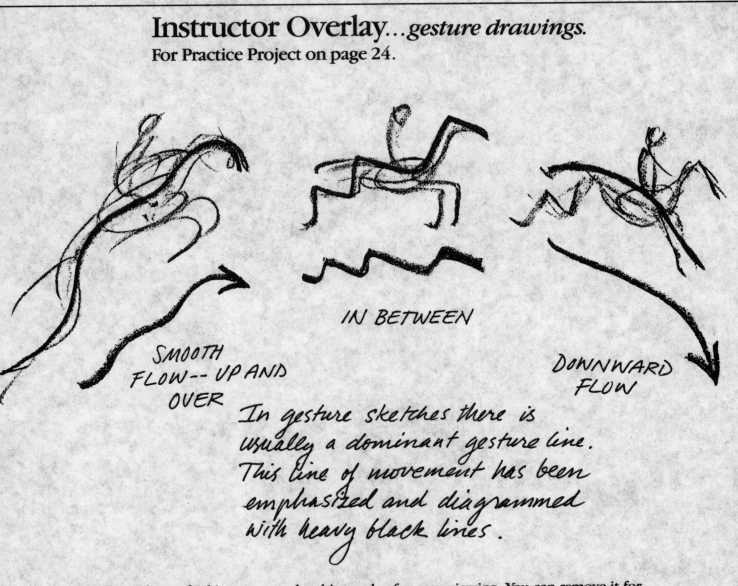

IN BETWEEN

SMOOTH FLOW -- UP AND OVER

DOWNWARD FLOW

*In gesture sketches there is usually a dominant gesture line. This line of movement has been emphasized and diagrammed with heavy black lines.*

Slip a sheet of white paper under this overlay for easy viewing. You can remove it for comparison with your Practice Project. You'll find these suggestions from an Instructor of the Famous Artists School most helpful.

# Tracing Papers ... the following pages include these items:

**11 Instructor Overlays.** These demonstrations show how instructors at Famous Artists School completed the Practice Projects. Remove them to compare them with your own project drawings.

**5 Blank sheets of tracing paper.** These will give you a chance to try out this useful and popular type of paper. Similar paper is readily available at stores selling art supplies.

**FREE ART LESSON.** This is the most important project of all. You'll find it at the end of the book. Complete it and mail it to get a free evaluation from the instruction staff of Famous Artists School.

**Note:** Slip a sheet of white paper under this page for easy reading.

---

# Instructor Overlay ... gesture drawings
### For Practice Project on page 24.

DOWNWARD FLOW

IN BETWEEN

SMOOTH FLOW—UP AND OVER

*In gesture sketches flow is
usually a downward gesture line.
This line of movement has been
emphasized and expressed
with heavy flexible lines.*

Slip a sheet of white paper under this overlay for easy viewing. You can remove it for comparison with your Practice Project. You'll find these suggestions from an instructor of the Famous Artists School most helpful.

# Instructor Overlay...*gesture drawings.*
For Practice Project on page 25.

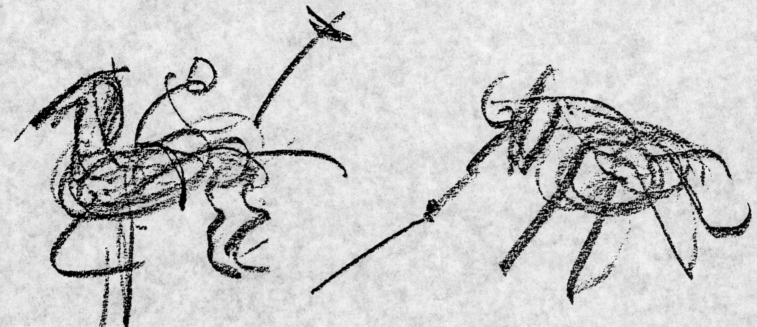

Unlike the jumping horses, with their continuous flow of action, these polo ponies are always pivoting and changing direction.

These crayon gesture sketches capture the necessary combination of balance and sudden speed —

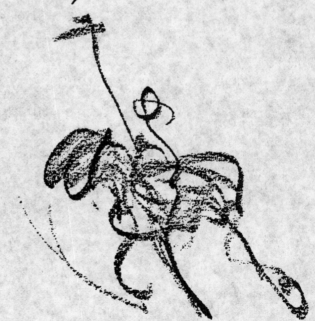

Slip a sheet of white paper under this overlay for easy viewing. You can remove it for comparison with your Practice Project. You'll find these suggestions from an Instructor of the Famous Artists School most helpful.

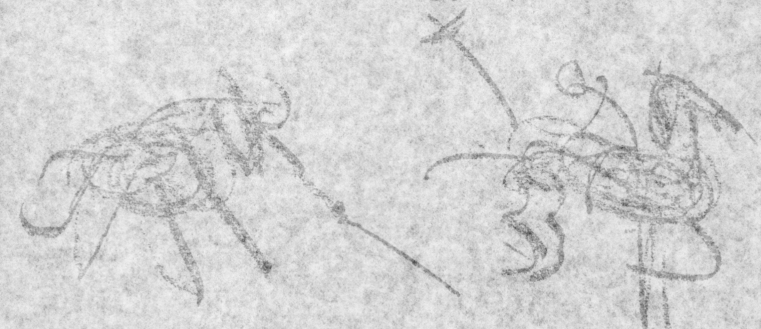

*These crayon gesture sketches capture the necessary exhilaration of balance and sudden speed —*

*Unlike the jumping horses, with their contortious flow of action, these polo ponies are always pivoting and changing direction.*

Slip a sheet of white paper under this overlay for easy viewing. You can remove it for comparison with your Practice Project. You'll find these suggestions from an Instructor of the Famous Artists School most helpful.

# Instructor Overlay...*basic form drawings.*

For Practice Project on page 34.

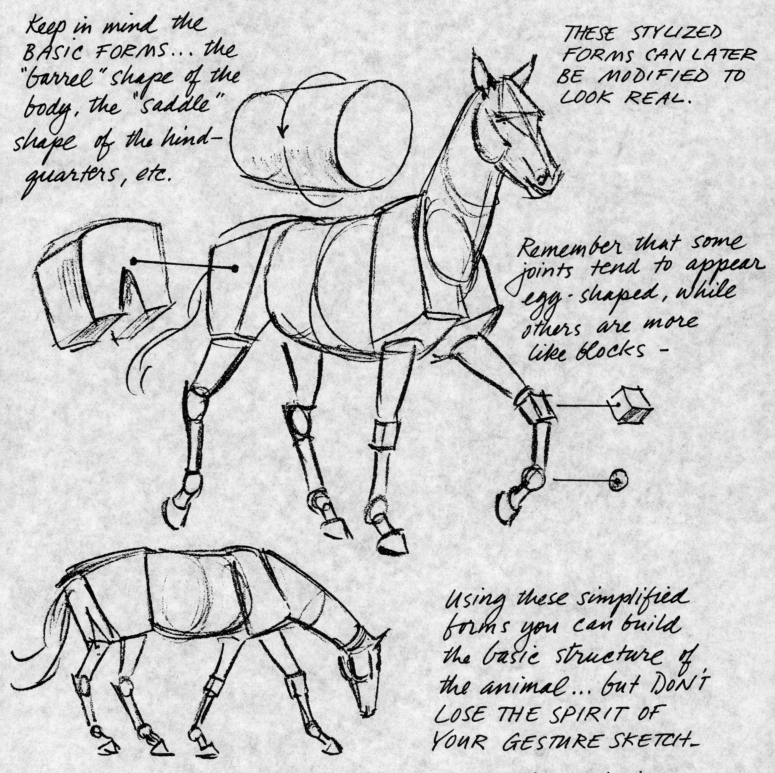

Keep in mind the BASIC FORMS... the "barrel" shape of the body, the "saddle" shape of the hind-quarters, etc.

THESE STYLIZED FORMS CAN LATER BE MODIFIED TO LOOK REAL.

Remember that some joints tend to appear egg-shaped, while others are more like blocks —

Using these simplified forms you can build the basic structure of the animal... but DON'T LOSE THE SPIRIT OF YOUR GESTURE SKETCH—

Slip a sheet of white paper under this overlay for easy viewing. You can also remove it and place it over your Practice Project for comparison and helpful suggestions from an Instructor of the Famous Artists School.

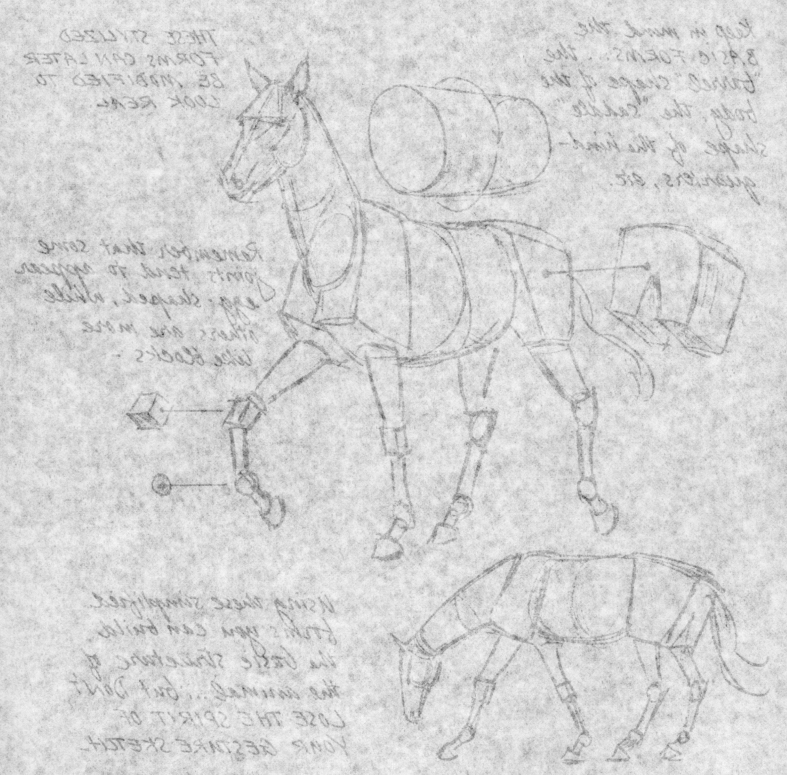

Instructor Overlay . . . basic form drawings.

For Practice Project on page 54

Slip a sheet of white paper under this overlay for easy viewing. You can also remove it and place it over your Practice Project for comparison and helpful suggestions from an instructor of the Famous Artists School.

# Instructor Overlay... *basic form drawings.*
For Practice Project on page 35.

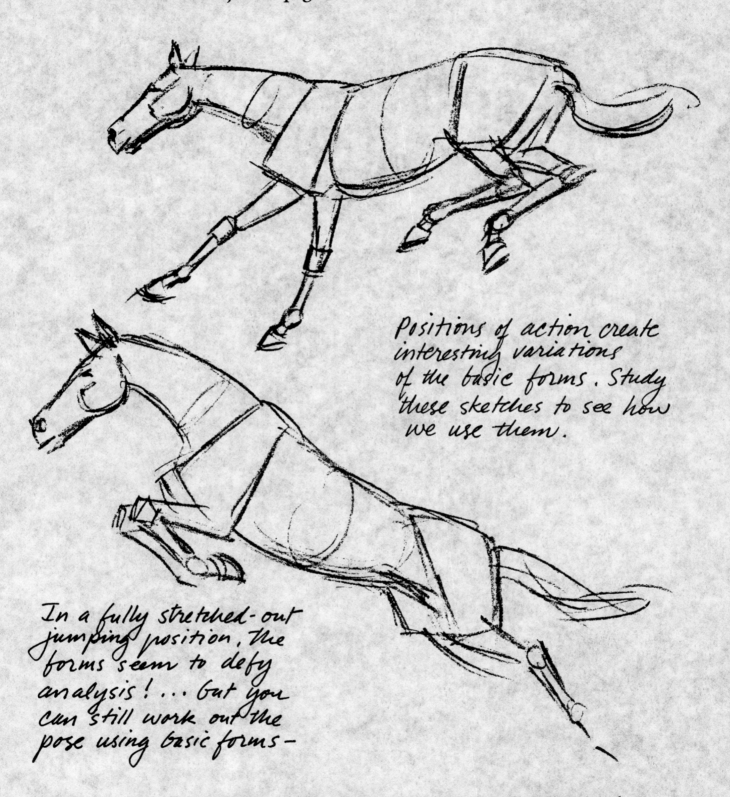

Positions of action create interesting variations of the basic forms. Study these sketches to see how we use them.

In a fully stretched-out jumping position, the forms seem to defy analysis! ... But you can still work out the pose using basic forms —

Slip a sheet of white paper under this overlay for easy viewing. You can also remove it and place it over your Practice Project for comparison and helpful suggestions from an Instructor of the Famous Artists School.

Positions of action create interesting variations of the basic forms. Study these sketches to see how we use them.

In a fully stretched-out jumping position, the forms seem to defy analysis!... Yet you can still work out the pose using basic forms —

Slip a sheet of white paper under this overlay for easy viewing. You can also remove it and place it over your Practice Project for comparison and helpful suggestions from an instructor of the Famous Artists School.

100

# Instructor Overlay...*horses.*

For Practice Project on page 44.

*The shoulder blade glides across the front of the ribs —*

*Here is the hip joint*

THIS SCHEMATIC DRAWING WILL HELP YOU UNDERSTAND THE WAY THE BONES MOVE INSIDE THE HEAVY MUSCLES OF THE HORSE IN ACTION.

*This projection is like our heel bone*

*The upper "arm" is encased in muscles —*

*This joint is like our elbow.*

*This joint is like our knee.*

*This corresponds to the ankle of a human.*

*A slight change in the tail keeps it from appearing to come out of the horse's hip.*

*Note how the colt's neck curves under its mother's body.*

*Even though the colt blocks out part of the mother's body, you should completely contrast both horses. At this stage, think of them as transparent.*

Slip a sheet of white paper under this overlay for easy viewing. You can remove it for comparison with your Practice Project. You'll find these suggestions from an Instructor of the Famous Artists School most helpful.

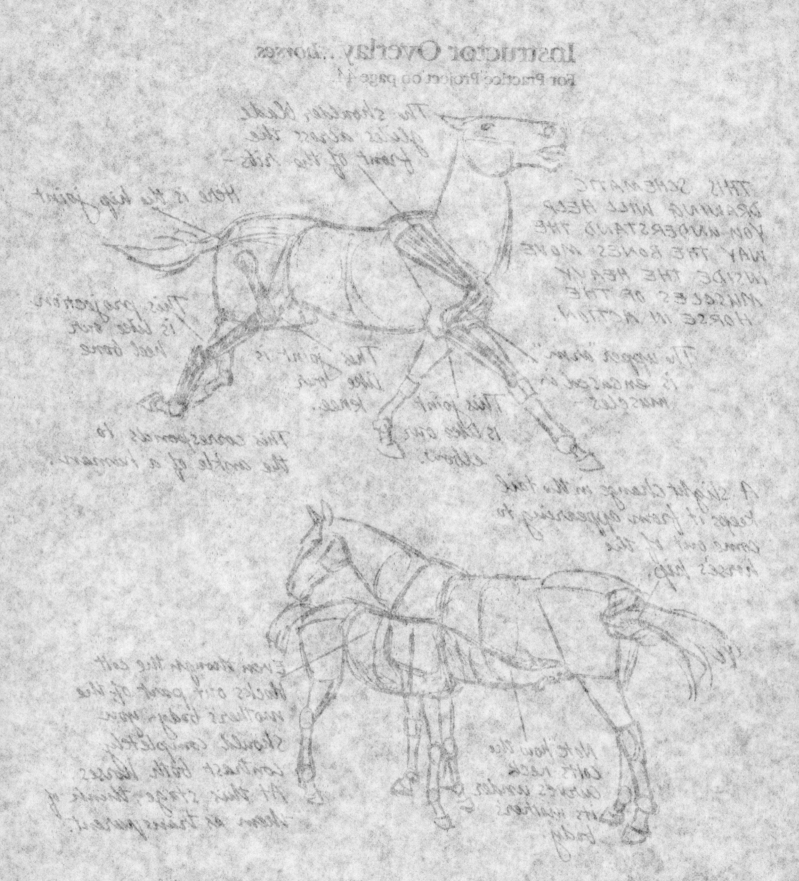

*"FLESHING OUT" THE BASIC FORMS.*
*We see here that exciting stage where*
*the blocked-in drawings become real.*

*Note how the gesture*
*... the feeling of life*
*and movement... has*
*been retained.*

*As the surface shapes*
*of muscles and bones*
*are developed, we must*
*not lose the solid, three-*
*dimensional forms...*
*the barrel-like body,*
*tube-like legs, etc.*

Slip a sheet of white paper under this overlay for easy viewing. You can remove it for comparison with your Practice Project. You'll find these suggestions from an Instructor of the Famous Artists School most helpful.

"FLESHING OUT" THE BASIC FORMS.
We see now that exciting stage where
the blocked-in drawing seems real.

Note how the gesture
...the feeling of life
and movement has
been retained.

As the surface shapes
of muscles and bones
are developed, we must
not lose the solid, three-
dimensional forms...
the barrel-like body,
tube-like legs, etc.

# Instructor Overlay...dogs.

For Practice Project on pages 52 and 53.

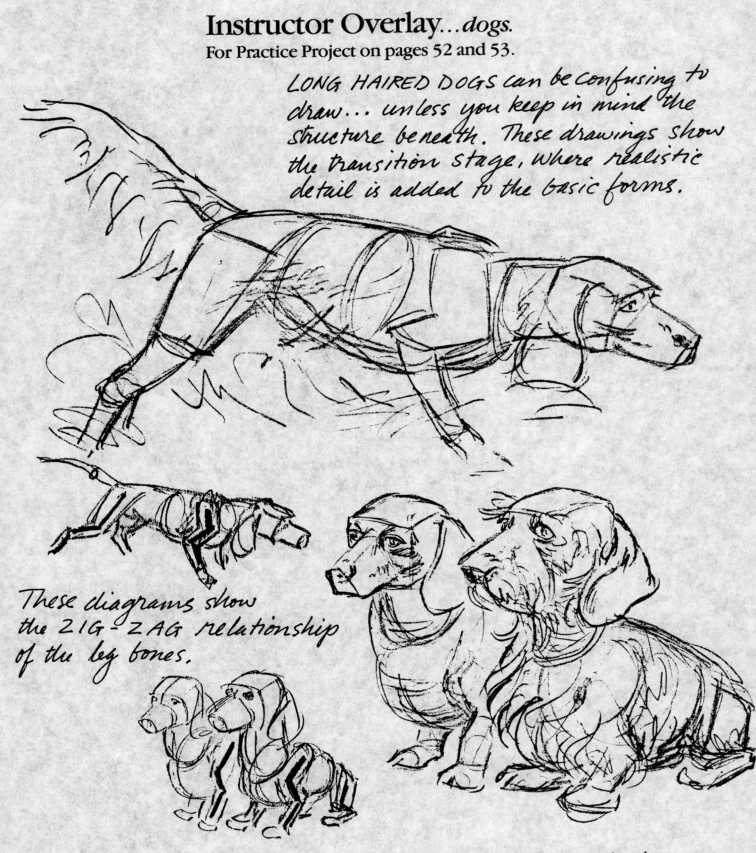

LONG HAIRED DOGS can be confusing to draw... unless you keep in mind the structure beneath. These drawings show the transition stage, where realistic detail is added to the basic forms.

These diagrams show the ZIG-ZAG relationship of the leg bones.

Slip a sheet of white paper under this overlay for easy viewing. You can also remove it and place it over your Practice Project for comparison and helpful suggestions from an Instructor of the Famous Artists School.

# Instructor Overlay . . . dogs

For Practice Project on pages 52 and 53

LONG-HAIRED DOGS can be confusing to draw . . . unless you keep in mind the structure beneath. These drawings show the transition stage where fur disappears and is added to the basic forms.

These diagrams show the 2:16 · 2:16 relationship of the leg bones.

Slip a sheet of white paper under this overlay for easy viewing. You can also remove it and place it over your Practice Project for comparison and helpful suggestions from an instructor of the Famous Artists School.

103

# Instructor Overlay...cats.

For Practice Project on pages 62 and 63.

The basic form method of "blocking in" is most effective when drawing cats in all positions

Establishing the center line helps make the forms work together

A cat can look like a mass of fur unless you keep in mind the solid structure beneath.

Slip a sheet of white paper under this overlay for easy viewing. You can also remove it and place it over your Practice Project for comparison and helpful suggestions from an Instructor of the Famous Artists School.

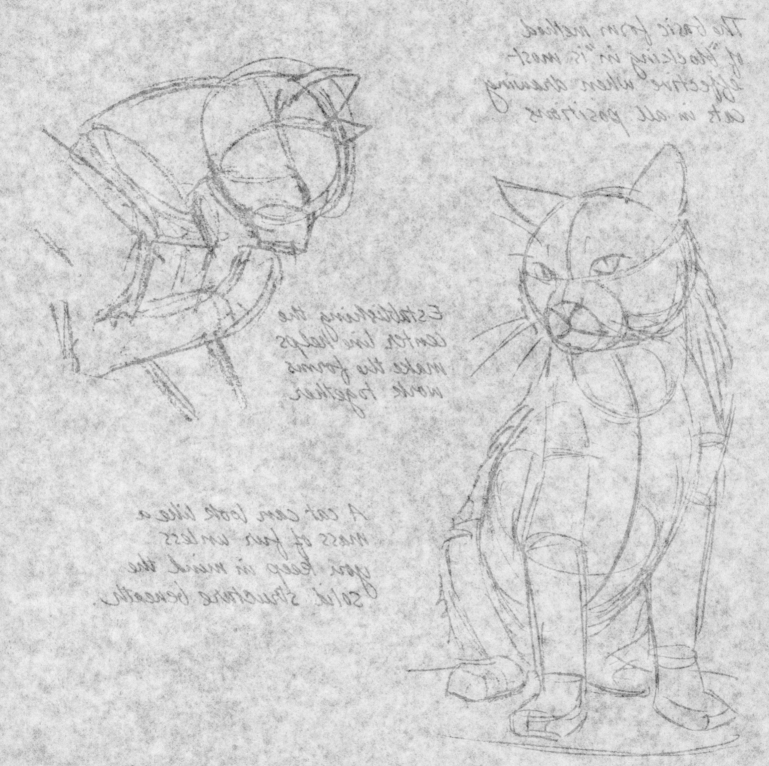

Slip a sheet of white paper under this overlay for easy viewing. You can also remove it and place it over your Practice Project for comparison and helpful suggestions from an Instructor of the Famous Artists School.

101

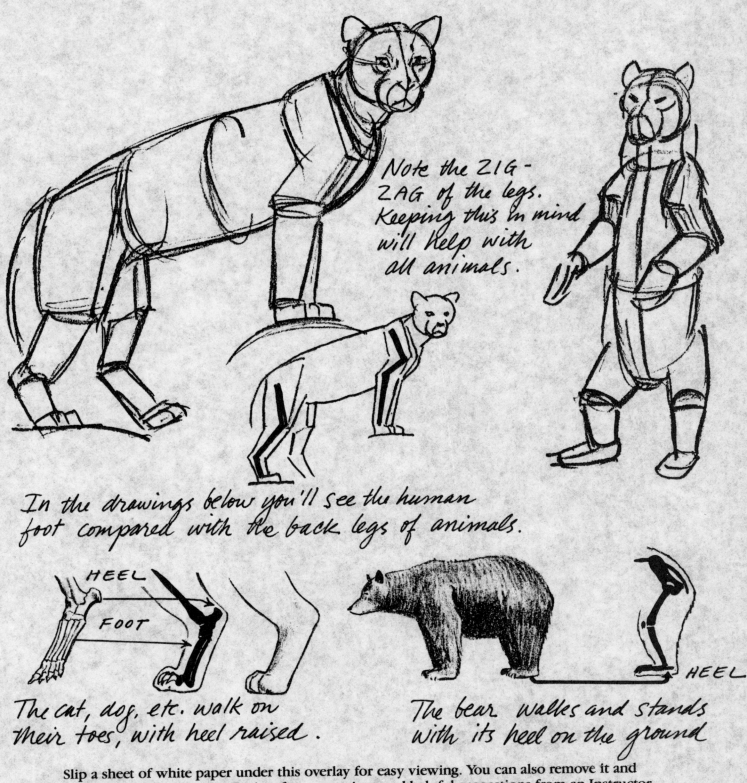

Note the ZIG-ZAG of the legs. Keeping this in mind will help with all animals.

In the drawings below you'll see the human foot compared with the back legs of animals.

HEEL

FOOT

HEEL

The cat, dog, etc. walk on their toes, with heel raised.

The bear walks and stands with its heel on the ground

TEAR OUT PAGE ALONG THE PERFORATION

*For Practice Project on page 86.*

Note the 21C - 24C to the left, keeping this in mind will help with all animals.

In the drawings below you'll see the human foot compared with the back legs of animals.

The cat, dog, etc. walk on their toes with heel raised.

HEEL

FOOT

HEEL

The bear walks and stands with its heel on the ground.

HEEL

Slip a sheet of white paper under this overlay for easy viewing. You can also remove it and place it over your Practice Project for comparison and helpful suggestions from an Instructor of the Famous Artists School.

# Instructor Overlay...*other animals.*
### For Practice Project on page 87.

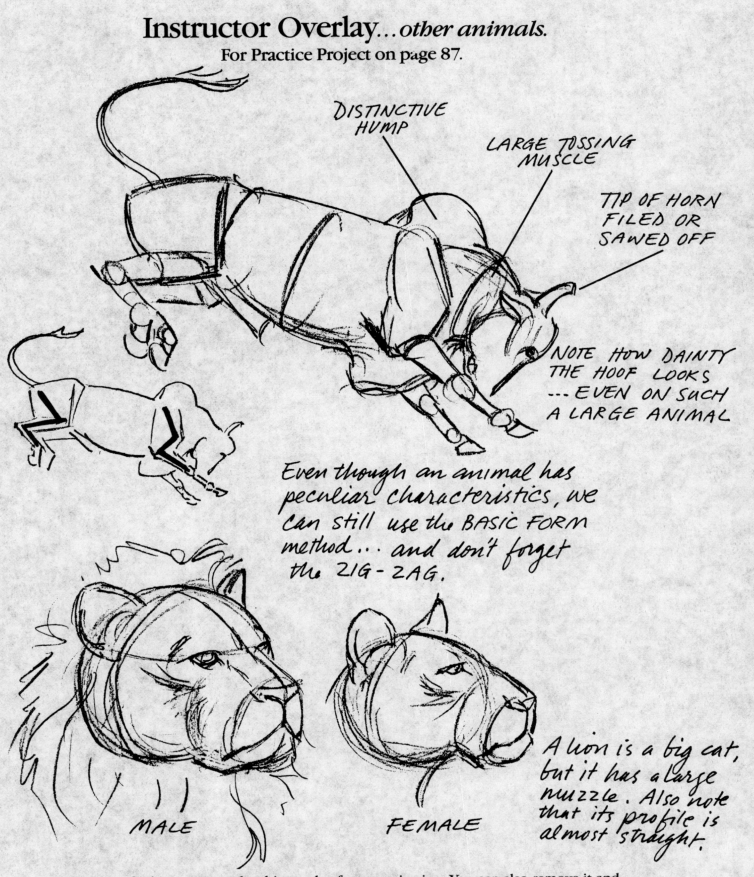

DISTINCTIVE HUMP

LARGE TOSSING MUSCLE

TIP OF HORN FILED OR SAWED OFF

NOTE HOW DAINTY THE HOOF LOOKS --- EVEN ON SUCH A LARGE ANIMAL

Even though an animal has peculiar characteristics, we can still use the BASIC FORM method... and don't forget the ZIG - ZAG.

MALE

FEMALE

A lion is a big cat, but it has a large muzzle. Also note that its profile is almost straight.

Slip a sheet of white paper under this overlay for easy viewing. You can also remove it and place it over your Practice Project for comparison and helpful suggestions from an Instructor of the Famous Artists School.

DISTINCTIVE HUMP

LARGE TOSSING MUSCLE

TIP OF HORN FILED OR SAWED OFF

NOTE HOW DAINTY THE HOOF LOOKS --- EVEN ON SUCH A LARGE ANIMAL

Even though an animal has peculiar characteristics, we can still use the BASIC FORM method ... and don't forget the 216-246.

A lion is a big cat, but it has a large muzzle. Also note that its profile is almost straight.

FEMALE

MALE

Slip a sheet of white paper under this overlay for easy viewing. You can also remove it and place it over your Practice Project for comparison and helpful suggestions from an instructor of the Famous Artists School.

# Instructor Overlay...*birds.*

For Practice Project on pages 94 and 95.

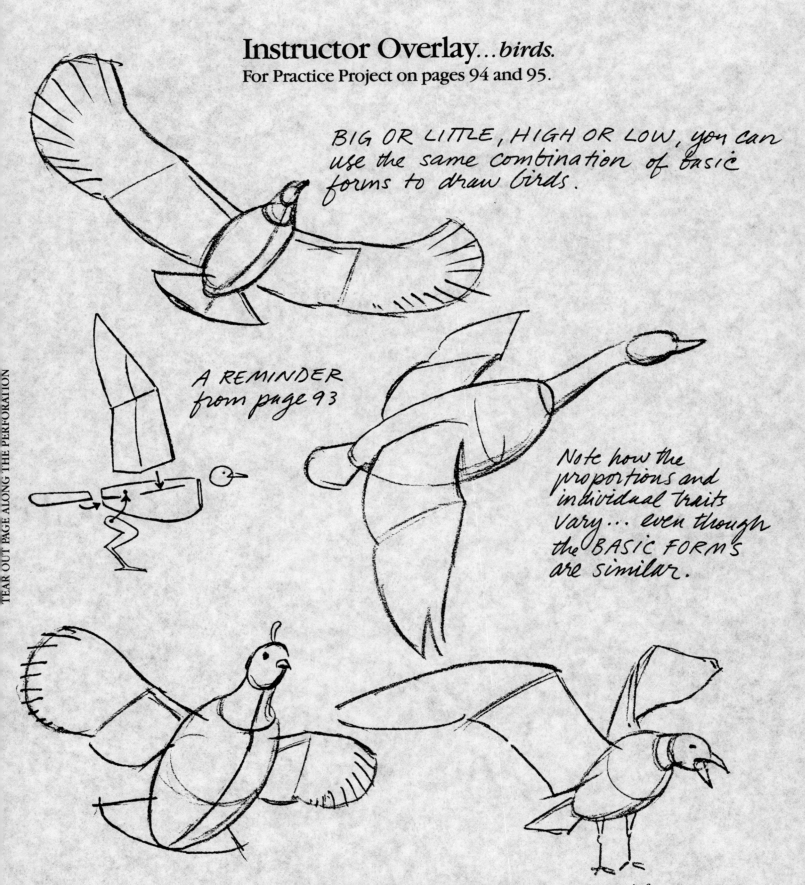

BIG OR LITTLE, HIGH OR LOW, you can use the same combination of basic forms to draw birds.

A REMINDER from page 93

Note how the proportions and individual traits vary... even though the BASIC FORMS are similar.

Slip a sheet of white paper under this overlay for easy viewing. You can remove it for comparison with your Practice Project. You'll find these suggestions from an Instructor of the Famous Artists School most helpful.

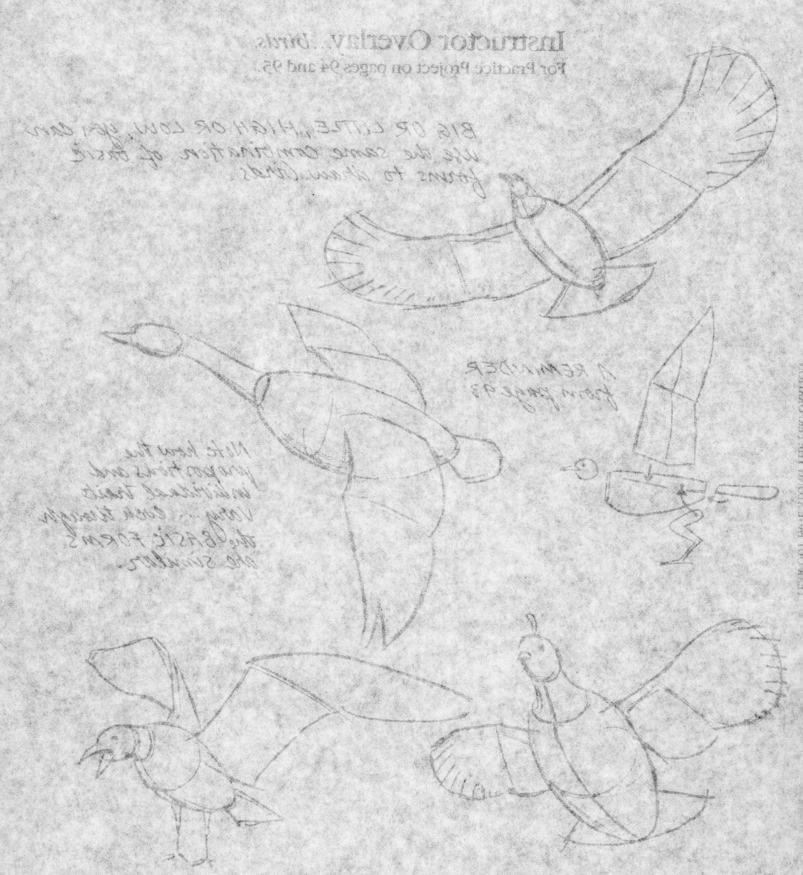

Slip a sheet of white paper under this overlay for easy viewing. You can remove it for comparison with your Practice Project. You'll find these suggestions from an instructor of the Famous Artists School most helpful.

107

**Tracing Paper.** These sheets will give you a chance to try out this useful and popular type of paper. Similar paper is readily available at stores selling art supplies.

**Tracing Paper.** These sheets will give you a chance to try out this useful and popular type of paper. Similar paper is readily available at stores selling art supplies.

**Tracing Paper.** These sheets will give you a chance to try out this useful and popular type of paper. Similar paper is readily available at stores selling art supplies.

**Tracing Paper.** These sheets will give you a chance to try out this useful and popular type of paper. Similar paper is readily available at stores selling art supplies.

**Tracing Paper.** These sheets will give you a chance to try out this useful and popular type of paper. Similar paper is readily available at stores selling art supplies.

Tracing Paper. These sheets will give you a chance to try out this useful and popular type of paper. Similar paper is readily available at stores selling art supplies.

# Famous Artists School

## invites you to enjoy this valuable FREE Art Lesson

Just complete this FREE Art Lesson using your own natural talents and what you have learned from this step-by-step method book. The Lesson covers several areas of artistic development. Then fill in the information on the reverse side, fold as indicated and mail to Famous Artists School. A member of our professional Instruction Staff will personally evaluate your Special Art Lesson and return it to you with helpful suggestions. You will also receive information describing the complete Famous Artists School courses which will open up a world of personal satisfaction and creative achievement for you. No obligation—this personal evaluation and information are yours absolutely free. Don't miss this important opportunity—mail this valuable Art Lesson today.

### Picture composition...how shapes fit together

- All pictures are composed of shapes. Objects in a picture are called positive shapes. The remaining areas are negative shapes. Indicate the total number of separate shapes, both positive and negative, that you see in the design at right.

*In this example there are two shapes*

one   two   three   four   five   six

### Observation...part natural and part learned

- On a bright, sunny day, the color of green leaves on a tree looks
  - a) yellow-green in sunlight and blue-green in the shadows
  - b) blue-green in sunlight and yellow-green in the shadows
  - c) the same in sunlight and shadow

- Which triangle appears closest to you?

A       B       C

- Half close your eyes as you look at these four panels. While squinting, which one appears to be the darkest?

A          B          C          D

### Lighting...shadow pattern reveals form

- Diagram A shows the way the shadows would look if there was one light source as shown. Using a pencil or pen, shade in how the shadows would fall on Box B with the same light.

A          B

Using an ordinary soft pencil, complete this outline drawing of a dog by drawing in the shading to give it solid form. Notice in the drawing above how the strong, simple lighting creates a contrasting pattern, separating light and shaded areas.

**INSTRUCTOR'S COMMENTS:**

## *Like to Learn More About Drawing Animals?*

### You can…with Famous Artists School's time-tested method.
### Get started today with this valuable art lesson.

**THIS OFFER IS AVAILABLE ONLY IN THE UNITED STATES AND CANADA.**

This side out for mailing. Fold in half along broken line.

Mr.
Mrs.
Miss_____
Ms
Address_____ Apt. No. _____

City_____ State _____ Zip_____

Telephone Number ( )_____
        (area code)

PLACE
PROPER
POSTAGE
HERE

**FAMOUS ARTISTS SCHOOL**
**Dept. FAN**
**17 Riverside Avenue**
**Westport, CT 06880**

**First Class Mail**

*ATTENTION:*
**Instruction Department**
FREE ART LESSON